IMAGES
of America

NEW BRITAIN
VOLUME III

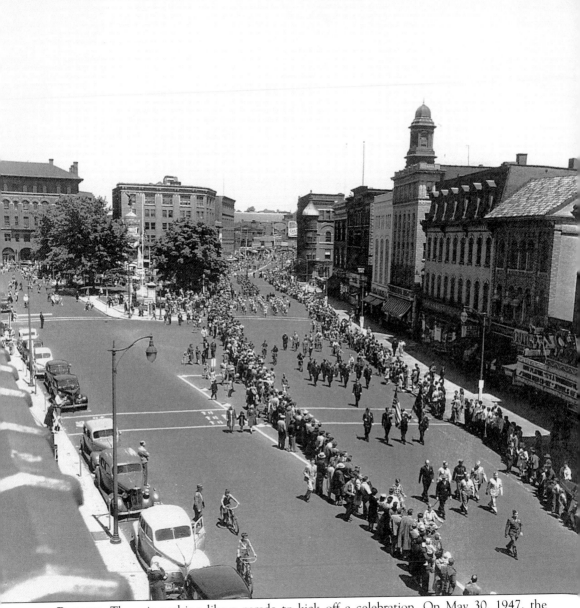

PARADE. There is nothing like a parade to kick off a celebration. On May 30, 1947, the Memorial Day parade was held downtown. Crowds lined the street at the south end of Central Park, eagerly awaiting the procession. With the advent of the city's sesquicentennial in the year 2000, residents are looking forward to a year-long celebration. (Charles J. Sullivan.)

IMAGES
of America

NEW BRITAIN
VOLUME III

Arlene C. Palmer

ARCADIA
PUBLISHING

Published by Arcadia Publishing
Charleston SC, Chicago IL, Portsmouth NH, San Francisco CA

Printed in the United States of America

Library of Congress Catalog Card Number: 2007939580

For all general information contact Arcadia Publishing at:
Telephone 843-853-2070
Fax 843-853-0044
E-mail sales@arcadiapublishing.com
For customer service and orders:
Toll-Free 1-888-313-2665

Visit us on the Internet at www.arcadiapublishing.com

*To the memory of Manny Campanario,
who was a bright light in a dark place.*

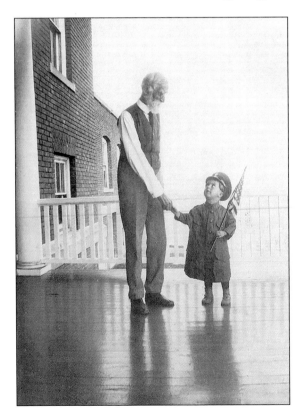

FAMILY. The father of Mrs. J.E. Klingberg and a little friend celebrate together. The Klingberg Family Center continues to reach out to children in need. (Klingberg Family Center.)

CONTENTS

ACKNOWLEDGMENTS

Many of the images recorded here were borrowed from the Local History Room photo archives of the New Britain Public Library and the *Herald* photo files. Many thanks to these organizations for their cooperation. Once again, private individuals were most generous in sharing their family photographs for all to enjoy. It is with great appreciation that I acknowledge the following: Rosemary Agnostinucci, the American Association of University Women, Christine C. Balint, Eugenia C. Banios, Richard Barrows, Eleanor Z. Benson, Nobel Ray Benson, James Boccuzzi, Phobe Lucille Bomer, Jim and Alison Buckwell, Alan Burstein, Allen Butte, Don Clerkin/New Britain Sports Hall of Fame, the Connecticut State League of Women Voters, the Copley Estate, Cas Cosina, James J. DaMico, Orlando Dolce, George Georgiasis, G. Paul Hagist, Fred Hedeler, Ernest Horvath, Frances Jacob/New Britain Musical Club, Mark Johnson and the Klingberg Family Center, Nicholas Lampros, Robert J. McCran, Erin Morran, Dennis Morrell, P.B. Morse, Mr. and Mrs. Howard Needham, the New Britain Museum of American Art, Tony Norris, Gene Ostroski, Daniel J. Palmer, Hoyt C. Pease, Deborah Pfeiffenberger/Youth Museum, Patricia Po, Joan Rhinesmith/CW Group, Inc., Mary and Matthew Rubino, Ada Seaman, Steve Sicklick, Susan Stein, Marie Venberg, Ray Venberg, Margaret Knight Verzulli, and Barbara Yezierski.

I would especially like to thank retired photographer Charles J. Sullivan, for so generously sharing his work and his memories of the city with me. All names throughout the text have been recorded as accurately as possible.

INTRODUCTION

From farming community to industrial giant, New Britain, a small area of 13.2 square miles, has a history that embraces nationalities worldwide. Once part of the town of Farmington, settlers in this area broke away and became part of the Kensington Society (Berlin). By 1754 these pioneers decided to form their own parish. The organization of the First Church of Christ in 1758 established this area as an Ecclesiastical Society. Colonel Isaac Lee, a veteran of the Revolutionary War, chose the name New Britain in honor of the country of Great Britain.

By 1850 the society, once primarily a rural community, began its steady evolvement into an industrial giant. Original settlers included family names that would become synonymous with industry: North, Lee, Hart, Judd, and Booth. Stanley Works, a name equated with excellence, has maintained its New Britain roots since Frederick T. Stanley opened his bolt manufactory in 1843. On June 18, 1850, New Britain was incorporated as a town. With the development of the railroad and the success of other industries, the town fathers once again petitioned the State General Assembly. The State Senate and the House of Representatives approved New Britain's incorporation as a city on July 15, 1870. The freemen of the borough of New Britain then voted, by a margin of one, to incorporate on January 13, 1871.

As industry flourished, the need for a labor force grew. Immigrants found not only a haven but also means to make a decent living. By the mid-1800s the influx of immigrants began and has yet to stop. People of all nationalities have come to call New Britain home, and in recent years the slogan, "New Britain: A City For All People" was adopted. With the advent of modern technology, the face of manufacturing has changed the city. Today, New Britain's strengths lie within the service sector of the economy. New Britain General Hospital, the city's largest employer, and the newly opened Superior Courthouse exemplify this trend of people rather than products.

The city is a cultural mecca offering an outstanding array of arts. The New Britain Museum of American Art, live theater, the symphony, opera association, and countless concerts and multi-ethnic festivals provide city and area residents cultural experiences that satisfy all ages.

The year 2000 will mark New Britain's sesquicentennial—the 150th anniversary of its incorporation as an independent town. The following pages are a salute to the industries and associations, but most importantly, to the men and women who have helped New Britain thrive. The chapters on mayors, other leaders, and their accomplishments may prove to be historically significant, but the future of the city still remains with its children. Therefore the last chapter, "Remember the Children," becomes the most important.

—Arlene C. Palmer
May 1999

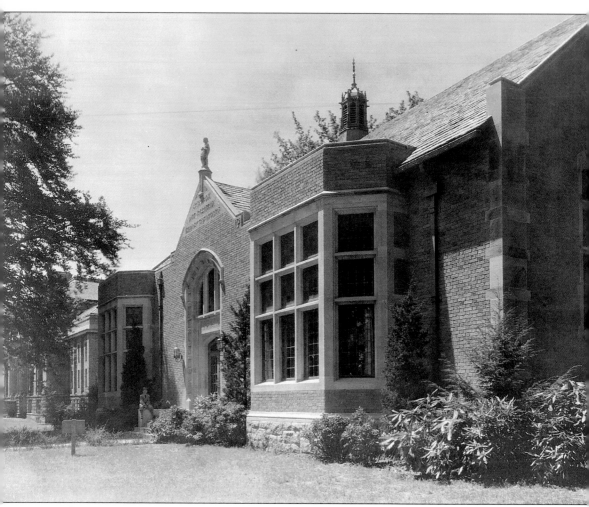

HAWLEY MEMORIAL CHILDREN'S LIBRARY. Upon Benjamin Hawley's death, he left the New Britain Institute substantial funds to benefit the city's children. The Hawley building houses the Children's Department of the New Britain Public Library, whose staff continuously provide area children with excellent service. (Local History Room/NBPL.)

One

CELEBRATIONS

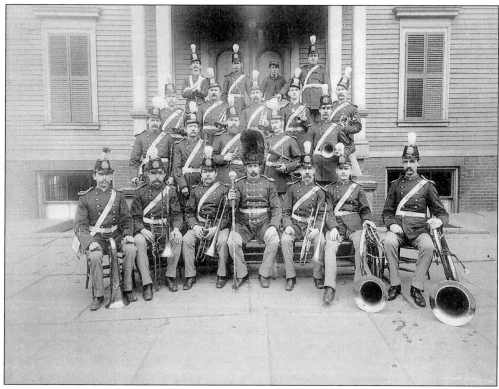

CITY BAND. Rudolf Ray, clarinet player, was the leader of this early band. A brass molder at Corbin, he still found time to lead this group of enthusiastic musicians in the mid-1800s. Music, like sports, has played an important role in the social development of the city. (Nobel Ray Benson.)

JAMES McALOON FAMILY. Following the early settlement of New Britain by people of primarily British descent, the first wave of immigrants hailed from Ireland. The McAloons, who came from County Fermanagh, posed for a formal portrait. (Dennis Morrell.)

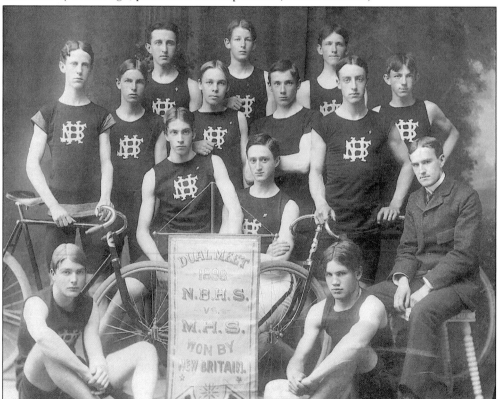

BICYCLISTS, C. 1896 These New Britain High School athletes celebrated their defeat of an area high school team. Although victorious, one could not tell by their solemn expressions. (Hoyt C. Pease.)

MRS. MAE CARNEY AND HER DAUGHTER MARY. The decision of a young woman to enter religious life is solemn, but is also a cause for celebration. On May 28, 1950, a party was given in Mary's honor by Mrs. Mathew Clark and her daughter Nancy. The fete was held at the Hotel Burritt on the eve of the young woman entering the convent. (Nancy Clark.)

CHRISTMAS LIGHTING CEREMONY. The annual tradition of "throwing the switch" to turn on the Christmas lights fell to young Richard Morrelli in 1956. Richard's father, then Mayor Joseph Morrelli, proudly looks on. (Local History Room/NBPL.)

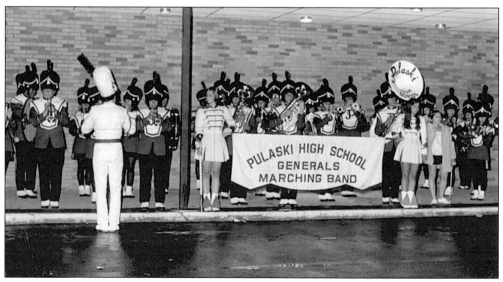

PULASKI HIGH MARCHING BAND. Pulaski High School has been gone for almost 20 years. This performance at Stanley Plaza on Slater Road helped promote ticket sales to the final event held at the Strand Theater in 1972. (Local History Room/NBPL.)

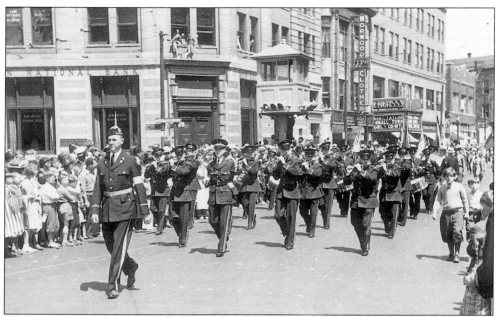

TABS DRUM CORPS. The Young Men's Total Abstinence and Benevolence Society Drum Corps was a feature in the 1936 Memorial Day Parade. The traffic tower, Embassy Theater, and the Gates Building (sans facade) are all but a memory. (*Herald.*)

CENTENNIAL PARADE. In 1971 parade viewers watch the festivities from the windows of the Gates Building. Thousands attended the celebration of New Britain's 100th anniversary of incorporation as a city. (*Herald.*)

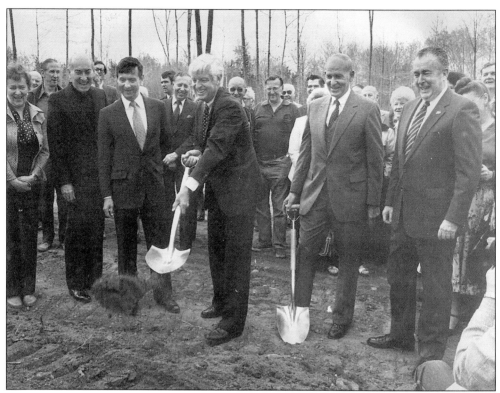

STANLEY WORLD HEADQUARTERS GROUND-BREAKING. Solidifying the company's commitment to the community in which it was founded, dignitaries broke ground for new headquarters on May 23, 1983. (*Herald.*)

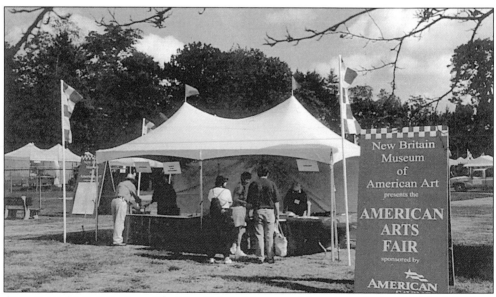

AMERICAN ARTS FESTIVAL. The New Britain Museum of American Art has enriched the lives of many. In September 1998, a combined celebration of a Grandma Moses exhibit and arts fair drew hundreds to Walnut Hill Park. (N.B. Museum of American Art.)

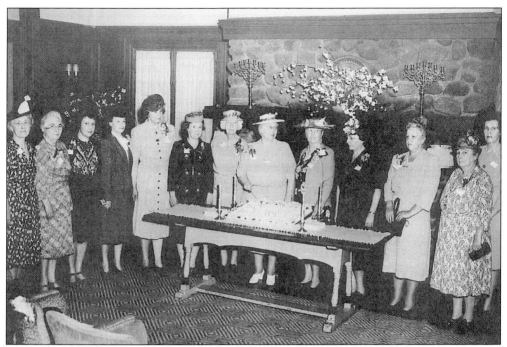

LEAGUE OF WOMEN VOTERS. The league strives to make city residents more aware of how they are governed. Members congregate for a portrait in 1947 to celebrate the organization's 25th anniversary. (League of Women Voters.)

AAUW. The American Association of University Women has been one of the most active organizations in the city. Past presidents include the following, from left to right: (seated) Fran Brautigam, Ruthe Boyea, Ruth Kimball, Pauline Alt, and Marguerite Larson Rhodes; (standing) Carol Peterson, Helen Pearl, Jennie Dubicki, Catherine Tamburro, Ruth Allen, Dora Stoutenberg, Celestine Casa, Emilie Uukna, Paula Yubna, and Linda Smythe. (AAUW/ NB Chapter.)

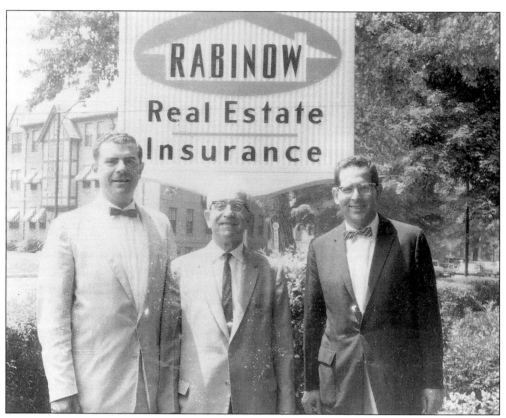

RABINOW INSURANCE CO. In an era when many small businesses are unable to survive, the Rabinow Agency is about to celebrate its 75th anniversary. Pictured in 1962 are, from left to right, Daniel Burstein, Louis Rabinow, and Thirschel Rabinow. (Alan Burstein.)

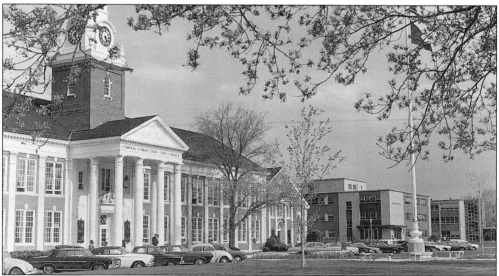

CCSU. Founded in 1850, the year 2000 will mark a special anniversary for Central Connecticut State University. It began as a small Normal School downtown and evolved into the sprawling campus in the Belvidere area. (*Herald.*)

MEMORIAL DAY PARADE, 1912. Over 200 New Britain residents fought in the Civil War; 75 of them never returned. These photographs taken in front of city hall illustrate those who remained in 1912. The last local survivor of the war died in 1936. In September 2000, the Sailors and Soldiers Monument in Central Park, which was built to honor these veterans, will be 100 years old. *Winged Victory*, the statue that graces the top of the monument, is currently being repaired and will hopefully be re-instated in time for the anniversary. (Local History Room/NBPL.)

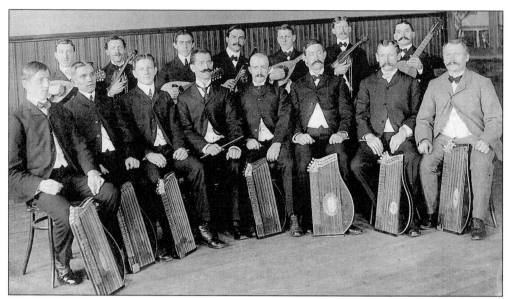

MUSICAL GROUPS. Music has always been an essential part of local culture. Members of the Zimmerman family were active in both featured groups. In the photograph above, Charles Zimmerman plays a lute *c.* 1900, while below, both Charles and Rudolf Zimmerman participate in the ensemble featuring guitar, banjo, and lute *c.* 1910. No matter how dire financial conditions were at the turn of the 20th century, music made problems easier to bear. (Eleanor Z. Benson.)

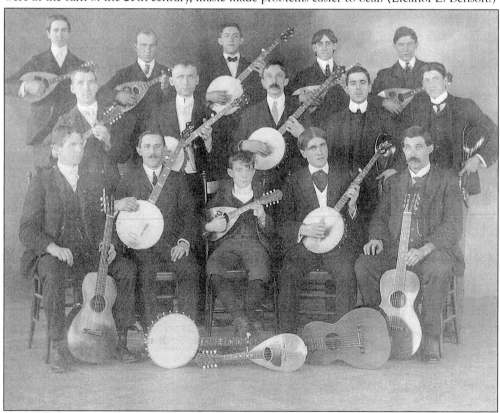

CHARLES HAMILTON. In 1910 residents were simultaneously stunned and pleased to look up above Walnut Hill Park and see local aviator Charles Hamilton fly overhead. The July celebration drew crowds from throughout the state. (*Herald.*)

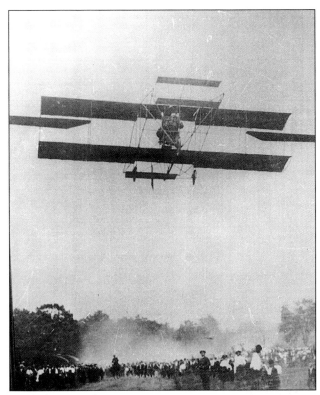

MAIN STREET USA. The largest multi-ethnic festival, Main Street USA began in 1976 and is held annually to mark the beginning of summer. It is the one time every year when all nationalities come together and celebrate the city's heritage. (*Herald.*)

MUSICAL CLUB. Among the many organizations celebrating the year 2000 is the Musical Club, which originated in 1920. Seen here performing at St. Jerome's, the mission of the club is to "promote musical culture in New Britain." (Fran Jacobs/NB Musical Club.)

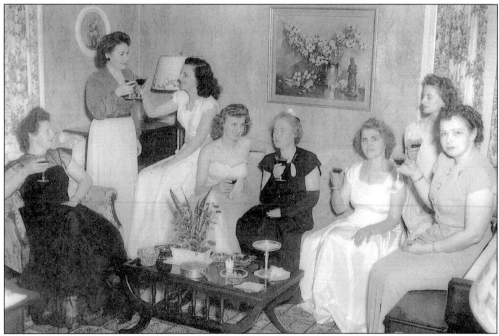

SEWING CIRCLE. This group of local ladies held their annual, end-of-the-year meeting in a most formal manner. Pictured at the 1950 party are, from left to right, Jean Paris, Helen Clark, Julie Ascare, Irene Charest, Ann Nyborg, ? Budnick, Claire Arseneault, and Mary Kiniry. (Nancy Clark.)

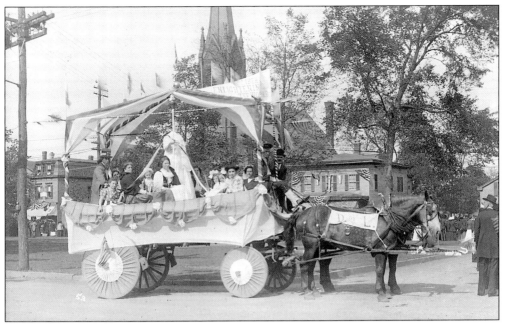

BURRITT DAY PARADE, 1910. The 100th anniversary of Elihu Burritt's birth was celebrated with a massive parade and elaborate ceremonies. The Daughters of Liberty prepared this float, entitled "The Goddess of Liberty." (Local History Room/NBPL.)

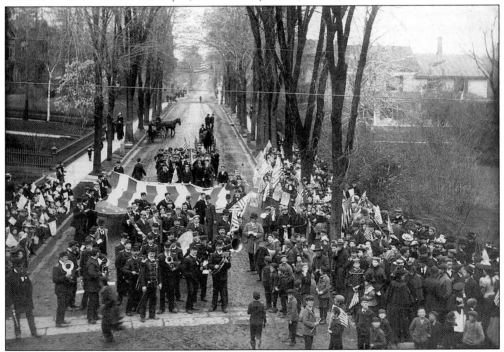

FOURTH OF JULY PARADE. New Britain's early rural nature is apparent in this view looking north on Washington Street from West Main Street. The churchyard, on the right, belonged to old St. Mark's. The wrought-iron fence is approximately where the Washington Diner now stands. (Local History Room/NBPL.)

ADOLF ANDERSON AND EMMA H. MACKER. Portraits often recorded events, whether it was to mark a term of military service or a wedding. Anderson, who belonged to the Connecticut National Guard, recalled the devastation of the 1906 San Francisco earthquake. During this time he was stationed in the Philippines. Upon his return home he married Emma Macker. (Mr. and Mrs. Howard Needham.)

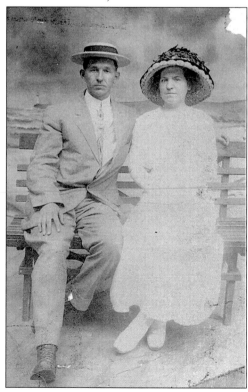

WEDDING PORTRAIT. Some early wedding outfits rival the formality of today's garb. In 1925 Mildred Johnson and Nils Eckberg posed for this remembrance. The yards of tulle on her veil enhanced the string of pearls, orange blossoms in her hair, and armful of roses. (Eleanor Z. Benson.)

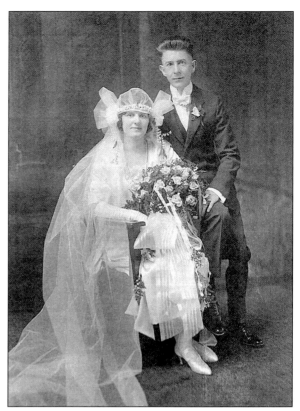

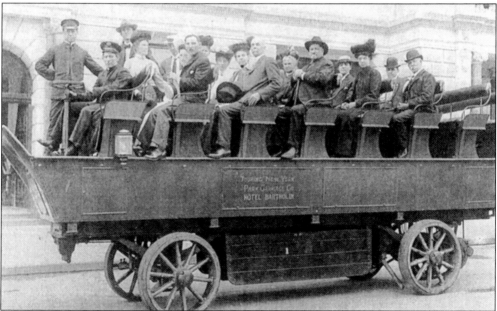

HONEYMOON. Some may have chosen lakes or mountains, but Rudy and Minnie chose to visit New York City. The open air carriage, provided by the Hotel Bartholdi, provided the newlyweds (seen directly behind the driver) with a bird's-eye view of the city. (Eleanor Z. Benson.)

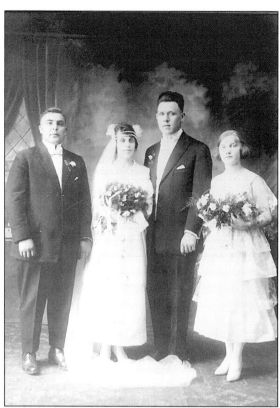

LEWICKI-OSTROSKI WEDDING.
Immigrants Janina Lewicki and
Stanley Ostroski were married in the
city in 1921. He served in France
during the First World War and came
back to work at Stanley Works. Their
sponsors were John Pudlik and Jean
Ciszczynski. (Gene Ostroski.)

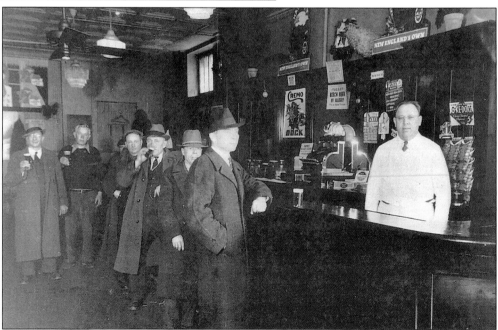

NUTMEG TAVERN. Ostroksi (far right) left his job at Stanley Works and opened a grocery store, followed by the Nutmeg Tavern in 1937. He ran it until 1941, when it was sold to Stanley Kulak, who renamed it the Half Dollar and later the Copper Penny. (Gene Ostroski.)

Two

THOSE WHO LED US
PART I

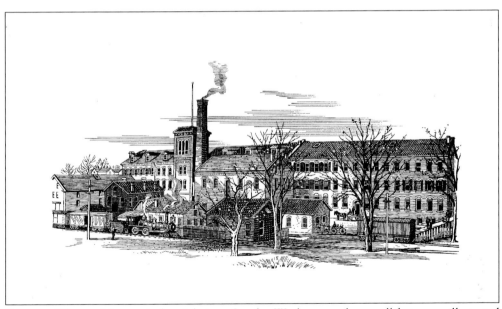

STANLEY WORKS. Now an industrial giant, Stanley Works was only a small factory, as illustrated in this print from an 1879 catalog. Industries and cities require strong leaders to make them grow. The following pages honor the men and women who have been instrumental in New Britain's success. (Local History Room/NBPL.)

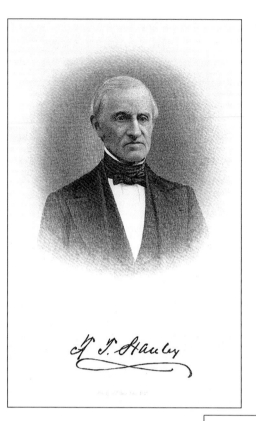

FREDERICK T. STANLEY, REPUBLICAN. He was New Britain's first mayor (1871–72) and, arguably, greatest industrialist. Although not politically motivated, Stanley was elected warden of the borough in 1850 and mayor in 1871. (Local History Room/NBPL.)

STANLEY BOLT MANUFACTORY. This is a price list page from Stanley's factory in 1854. From this small, wooden building would evolve one of the nation's greatest hardware producers, known throughout the world—Stanley Works. (Local History Room/NBPL.)

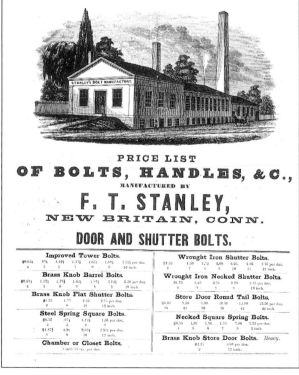

PRICE LIST
OF BOLTS, HANDLES, &C.,
MANUFACTURED BY
F. T. STANLEY,
NEW BRITAIN, CONN.
DOOR AND SHUTTER BOLTS.

DR. SAMUEL W. HART, REPUBLICAN.
A New Britain native, Hart attended
medical schools at Berkshire Medical
College, Harvard, and Yale. He
worked in European hospitals to gain
experience. His successful practice
in New Britain led to his election as
the second mayor (1872–77). (City of
New Britain.)

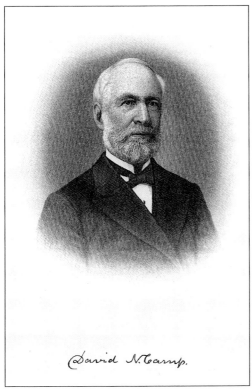

David N. Camp.

DAVID NELSON CAMP, REPUBLICAN.
New Britain's third mayor (1877–79) was
a professor of mathematics, geography, and
natural and moral philosophy. Camp was
highly influential in the development of the
Normal School. He became principal of the
school and later served as the superintendent
of the schools of Connecticut. (Local
History Room/NBPL.)

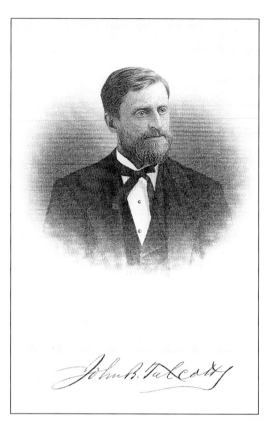

JOHN B. TALCOTT, REPUBLICAN. A graduate of Yale, Talcott studied law, worked as a probate court clerk, and tutored students in Greek and Latin. His community involvement included directorships at three banks, and he served on the Common Council before becoming the fourth mayor (1880–82). (City of New Britain.)

AMBROSE BEATTY, DEMOCRAT. The city's fifth mayor (1879–80, 1882–83, 1886–87) hailed from Clughill, County Longford, Ireland. He worked as a farmer before entering manufacturing. In addition to his work at Russell & Erwin and Landers, Frary & Clark, Beatty served in the fire department, state legislature, and local government. President Cleveland appointed him postmaster in 1887. (City of New Britain.)

J. ANDREW PICKETT, REPUBLICAN.
Pickett was an industrialist who was
affiliated with local concerns, including
A. North & Sons, Landers, Frary &
Clark, Russell & Erwin, American
Hosiery, and Stanley Rule & Level. New
Britain's sixth mayor (1883–86) was also
active in government, both state-wide
and locally. (City of New Britain.)

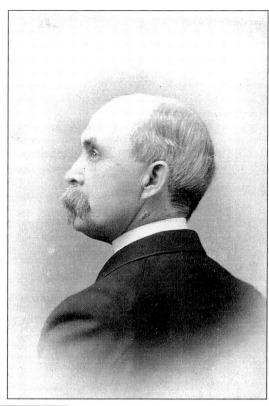

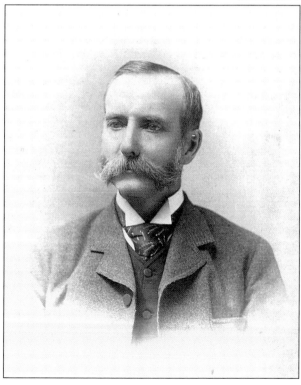

J. CLEMENT ATWOOD,
REPUBLICAN. Born in East Boston,
New Britain's seventh mayor
(1887–88) came to this city in
1872 to work for Landers, Frary
& Clark. He was an active Mason
and headed the Sunday school
at St. Mark's Church. (City of
New Britain.)

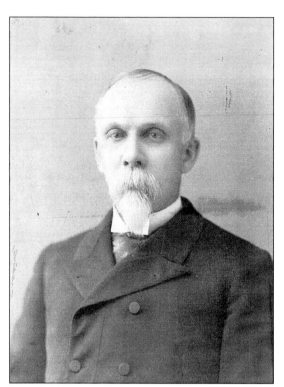

L. HOYT PEASE, REPUBLICAN.
Affiliated much of his life with Stanley Works, Pease was also president of the Burritt Bank and vice president of the Mechanics Bank. Previous to becoming mayor (1890–92), he was a councilman, alderman, and he served on both the school board and Republican Town Committee. (City of New Britain.)

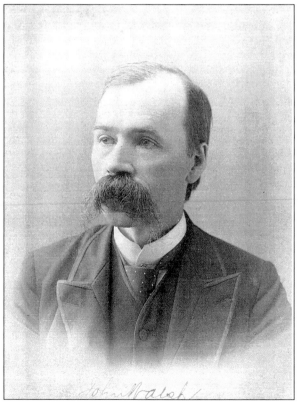

JOHN WALSH, DEMOCRAT. The ninth mayor of the city (1888–90, 1892–94) was only the second Democrat to hold that office. For 40 years he served on the school board as well as running a successful law practice and serving as probate judge. Born in Ireland, Walsh also worked for Corbin's and Landers, Frary & Clark before entering law. (City of New Britain.)

GEORGE W. CORBIN, DEMOCRAT. With the formation of Corbin Cabinet Lock, New Britain's tenth mayor (1894–96) became a salesman for the firm, later rising to secretary and president. His involvement with the community included the school board, local government, fraternal organizations, and directorships in area banks. (City of New Britain.)

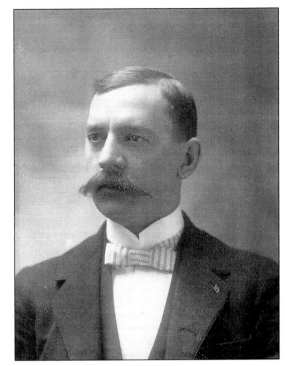

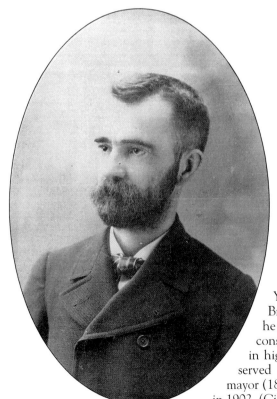

ROBERT J. VANCE, DEMOCRAT. Once employed by local industries, this New York native would gain fame as New Britain's premiere newspaperman. At age 22, he started the *New Britain Observer,* which consolidated with the *New Britain Herald.* Held in high esteem by those who knew him, Vance served in local and state government. The 11th mayor (1896–98) was only 48 years old when he died in 1902. (City of New Britain.)

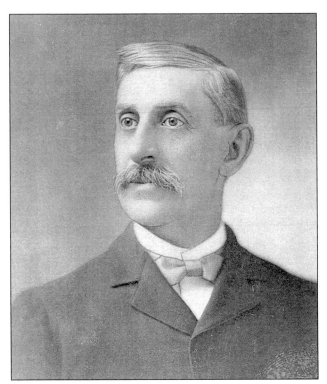

MORRIS C. WEBSTER, REPUBLICAN. A descendant of a Connecticut governor, the 12th mayor of New Britain (1898–1900) was born in Harwinton. It was 30 years later before he came to this city, where he worked for Malleable Iron Works and held positions in local and state government. (City of New Britain.)

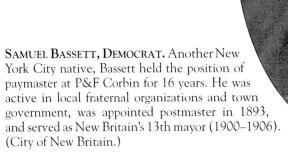

SAMUEL BASSETT, DEMOCRAT. Another New York City native, Bassett held the position of paymaster at P&F Corbin for 16 years. He was active in local fraternal organizations and town government, was appointed postmaster in 1893, and served as New Britain's 13th mayor (1900–1906). (City of New Britain.)

GEORGE M. LANDERS, REPUBLICAN/ DEMOCRAT. The city's 14th mayor (1906–10) holds the distinction of running unopposed. Initially, he was a Republican and then became a Democrat. A brilliant student, he went from Camp School directly to Yale. His work in industry included Landers, Frary & Clark and North & Judd. When he was only 56 years old, he died unexpectedly of pneumonia. (City of New Britain.)

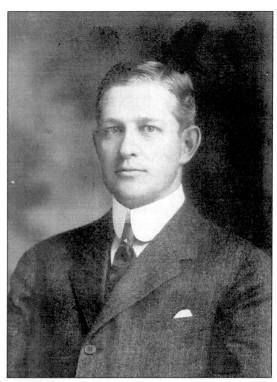

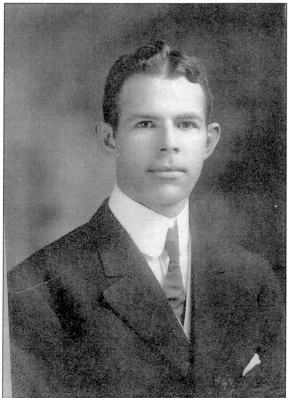

JOSEPH M. HALLORAN, DEMOCRAT. At the age of 30, he became the 15th mayor (1910–14). His love of the city came only second to his love of baseball. Leaving school early to help his family, Halloran worked as a clothier before being appointed postmaster. His involvement with local and state politics occupied his time until his death at age 93. (City of New Britain.)

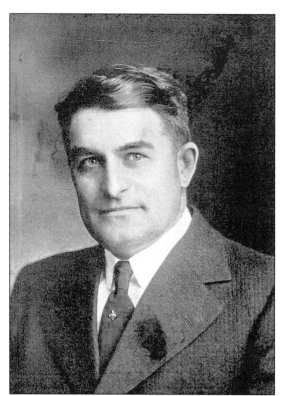

GEORGE A. QUIGLEY, REPUBLICAN. Active in local politics for 48 years, Quigley held the position of mayor (1914–20, 1930–34, 1936–38, 1942–46) for more terms than anyone else. His professional career included work at Russell & Erwin, the Vulcan Iron Works, the New Britain Knitting Co., and Landers, Frary & Clark. He was also involved in real estate, insurance, and contracting. His constituents often found him in his garden, his favorite pastime. (City of New Britain.)

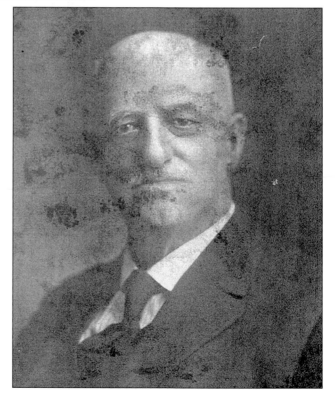

ORSON F. CURTIS, REPUBLICAN. It took Curtis six tries to become mayor before achieving that goal (1920–22). A carpenter and contractor by trade, his work included several local residences and public buildings. He maintained an avid interest in local politics and fraternal organizations throughout his life. (City of New Britain.)

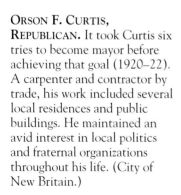

ANGELO M. PAONESSA, DEMOCRAT.
Born in Calabria, Italy, Paonessa
came to this country when he was ten
years old. His career involved work in
masonry and the automobile business.
Politically, he was active on both the
state and local level, and he twice
served as New Britain's mayor (1922–
26, 1928–30). (City of New Britain.)

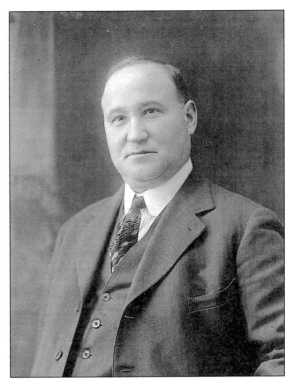

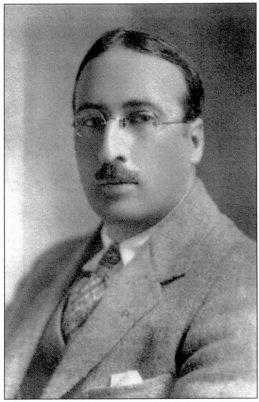

GARDNER C. WELD, REPUBLICAN. A
veteran of World War I, Weld devoted
most of his life to the family newspaper
business, the *Herald*. His interest in his
hometown encompassed local government,
scouting, a myriad of social and fraternal
organizations, and veterans' affairs. He also
served for several years as mayor of New
Britain (1926–28). (City of New Britain.)

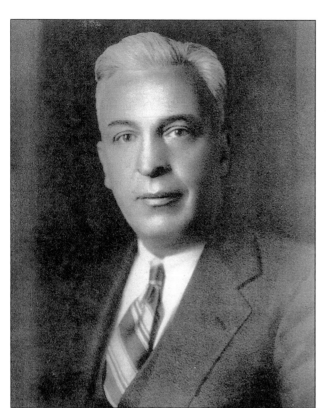

DAVID L. DUNN, DEMOCRAT. A New Britain native, Dunn was a respected attorney whose youth was largely devoted to sports. He participated in football, basketball, and baseball, distinguished himself in the sports arena at both Yale and Fordham University, and served for a term as mayor of New Britain (1934–36). (City of New Britain.)

GEORGE J. COYLE, DEMOCRAT. One of Coyle's greatest accomplishments was the establishment of the New Britain Memorial Hospital. An attorney by profession, the New Britain native devoted years to improving the city's water filtration system at Shuttle Meadow Reservoir, and served as mayor of New Britain for several years (1938–42). (City of New Britain.)

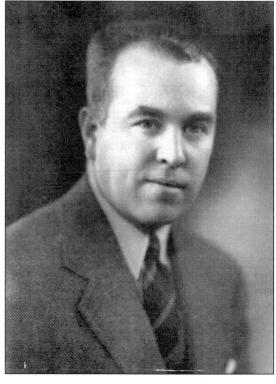

Three

THE HARDWARE CITY

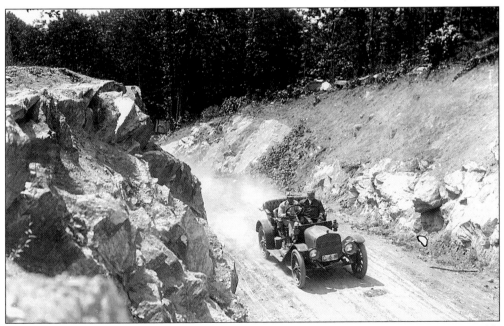

CORBIN CAR. "Horseless carriages" did not emerge solely from the Midwest. Beginning in 1903, the Corbin Motor Vehicle Corporation manufactured automobiles in New Britain. Production was in full swing by 1905, but owners of the firm intended to produce only 100 cars the following year. Plans went awry as orders far exceeded their expectation. The Corbin automobile won many endurance competitions and track races from Kansas City to Denver, Colorado. The Corbin was only one example of New Britain's manufacturing prowess. (Local History Room/NBPL.)

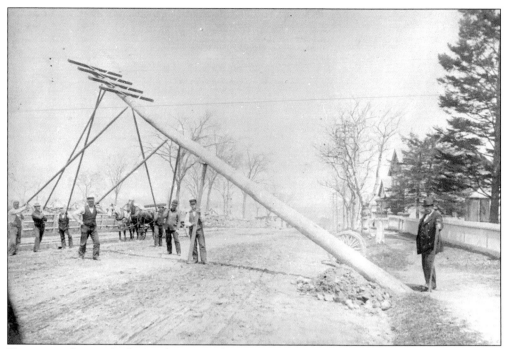

TELEPHONE LINES. As the Hardware City began to grow, a need for modern technology increased. In 1879 the Commercial Telephone Exchange opened on Main Street. On November 26, 1879, the Common Council allowed the firm to erect telephone poles on the streets. Originally, there were 25 subscribers, but within a year, the number had increased to 69. (*Herald.*)

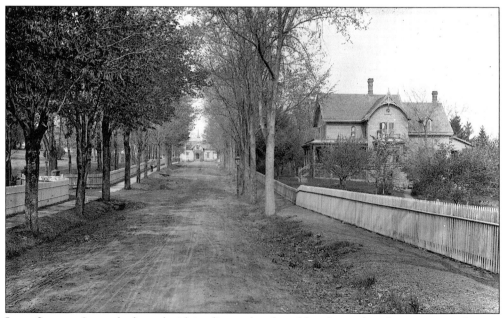

LAKE STREET. It may look rural with its dirt road and rambling lawns, but the street was adjacent to the Lockshop Pond, and a row of factories were located just beyond. James Shepard recorded this view of his street in 1884. (Local History Room/NBPL.)

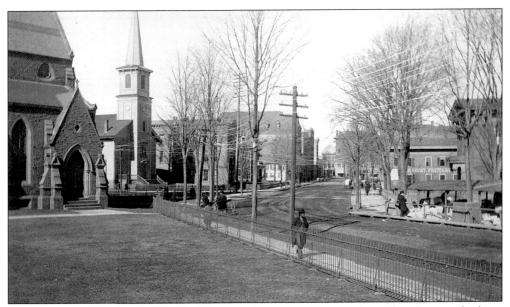

MAIN STREET C. 1890 AND 1923. What a difference 30 years makes! The photograph above was taken from the lawn of the South Congregational Church, looking north. The old Normal School is visible to the right. At the far end of the street, city hall is visible. Below is a similar view, taken from the middle of Main Street. Again, city hall lies just beyond the trees in Central Park. (Local History Room/NBPL.)

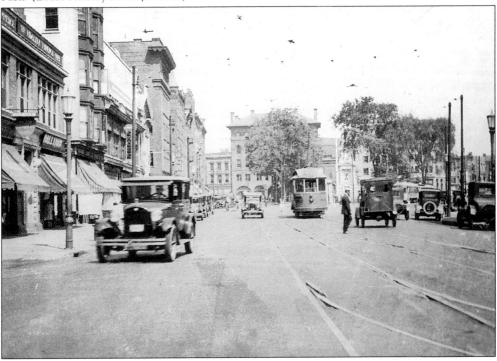

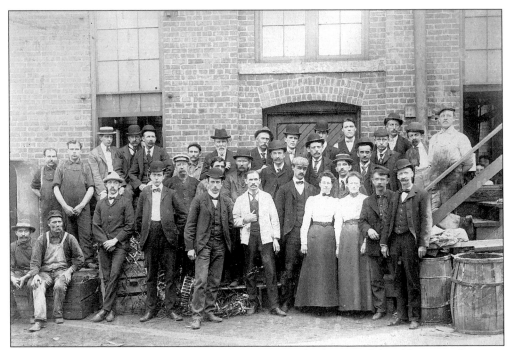

LANDERS, FRARY & CLARK MANUFACTURING. Reputed to be one of the oldest manufacturing companies in the country, Landers began operation in 1842. Josiah Dewey and George M. Landers produced furniture castings and hat-and-coat hooks. Landers eventually acquired a new partner, Levi O. Smith—thus the name changed again. As the company grew, the owners acquired other firms. By 1865, after a major reorganization, Landers, Frary & Clark incorporated. Cutlery was added to the line in 1866 and their famous "Universal" food chopper was patented in 1898. The small group of foremen/women pictured above in 1901 grew to include many more employees by the time the bottom photograph was taken in 1964. (Local History Room/NBPL.)

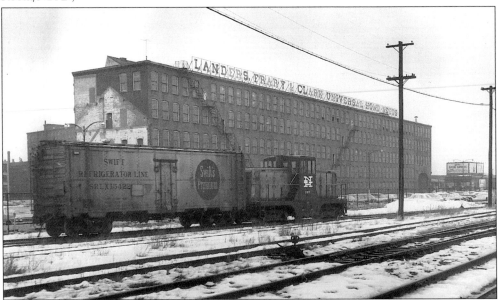

LANDERS, FRARY & CLARK PRODUCTS. Landers products facilitated the lives of housewives throughout the world. The Universal trademark could be found on just about any kitchen appliance: stoves, coffee makers, meat and food choppers, toasters, wafflemakers, vacuum cleaners, bathroom fixtures, and even sad irons. But in 1965, after 100 years of producing high quality products, the J.B. Williams Co. of New York bought most of the firm while the percolator division went to General Electric. Today Landers products are avidly sought by collectors and cooks alike. (Fred Hedeler/Local History Room/NBPL.)

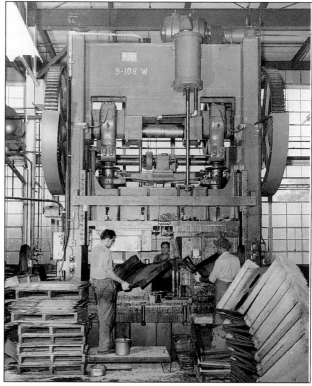

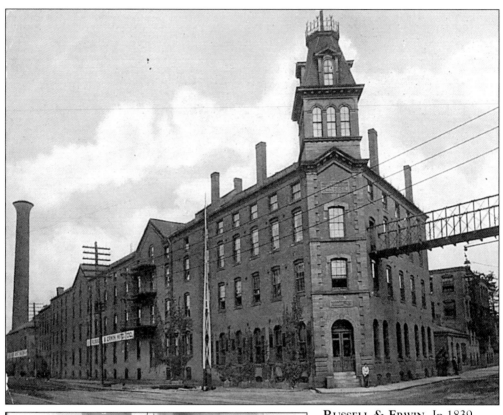

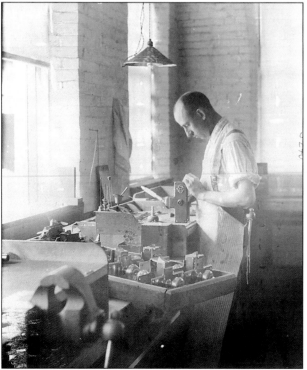

RUSSELL & ERWIN. In 1839 production of plate locks was undertaken by the founding fathers of Russell & Erwin. Company growth can be measured by early catalogs, which began with only 22 pages in 1849. By 1864 the catalog numbered 434 pages. The company incorporated in 1851. (Local History Room/NBPL.)

SAM HANNA, R&E LOCKMAKER. Russell & Erwin produced some of the most beautiful hardware in the world. Hotels, private residences. and public buildings such as the New York Public Library are filled with R&E products. (Local History Room/NBPL.)

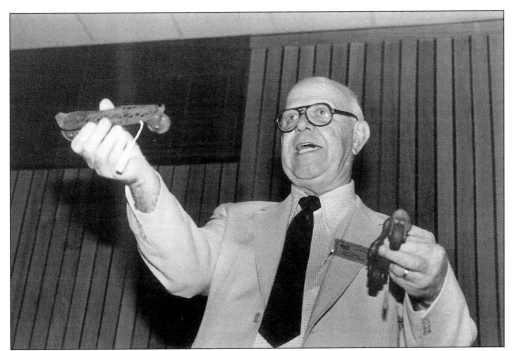

THREE-WHEELED ROLLER SKATES. The Stanley Rule & Level Co. produced these early skates in the mid-1860s. Fred Curry is holding what could be considered the forerunner of today's in-line skates. (*Herald.*)

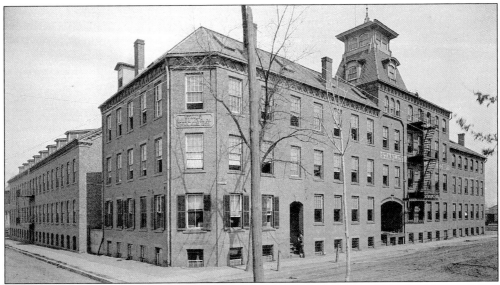

STANLEY RULE & LEVEL CO., C. 1898. In 1850 Augustus Stanley, T.A. Conklin, and Gad Stanley started the A. Stanley Co. Seth Savage's rule business in Bristol and Meriden were acquired; later Hall and Knapp were absorbed. The merger of these firms resulted in the incorporation of Stanley Rule & Level in 1858. Cocobola, vincolo, boxwood, rosewood, and other exotic woods were imported for use in their high quality rules and levels. (Local History Room/NBPL.)

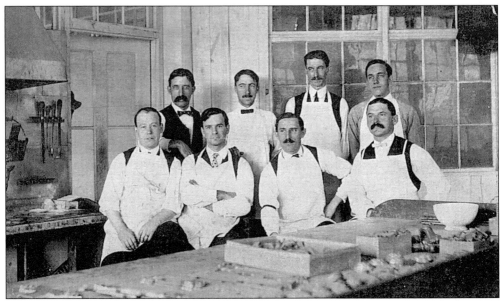

P&F CORBIN CHASING ROOM, 1905. Unlike today, workers often remained with the same company their entire lives. Rudolf Zimmerman, third from the left in the front row, began work and retired from Corbin, where he was a tool-and-die pattern maker. (Eleanor Z. Benson.)

CORBIN HARDWARE. This elaborate doorknob was designed in February 1901, the year before Corbin's merger with other firms to form the American Hardware Co. Corbin produced a whole series of specialized hardware, including doorknobs for all of the states in the country and many fraternal organizations. (Local History Room/NBPL.)

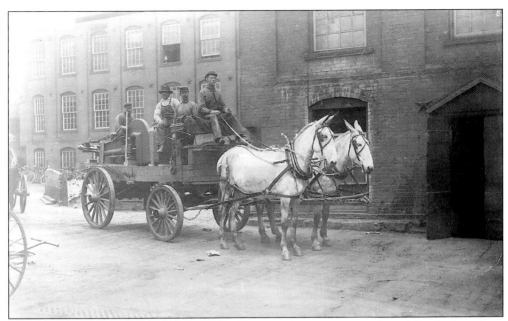

P&F CORBIN TEAM. A 1909 photograph illustrates how raw materials and finished products were transported within the area prior to motor vehicles. (Local History Room/NBPL.)

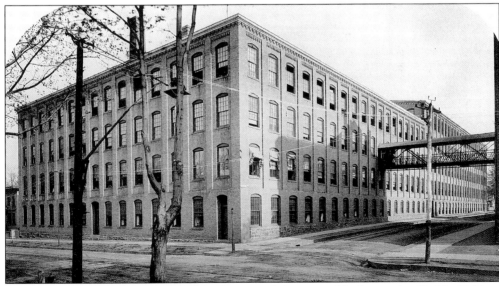

CORBIN CABINET LOCK CO. Another division of American Hardware, the Corbin Cabinet Lock Co. was headed by George W. Corbin. Today many Corbin locks are discovered gracing old steamer trunks, making them highly collectible. (Local History Room/NBPL.)

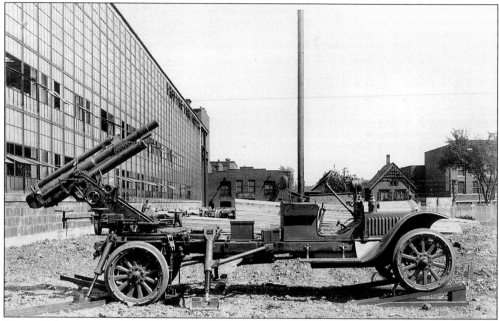

TRUCK MOUNT, 1917. Like many New Britain industries during a time of war, production of domestic goods ceased in order to fill governmental contracts. Seen here is an example of a truck mount; many of these were used on the front during World War I. (Local History Room/NBPL.)

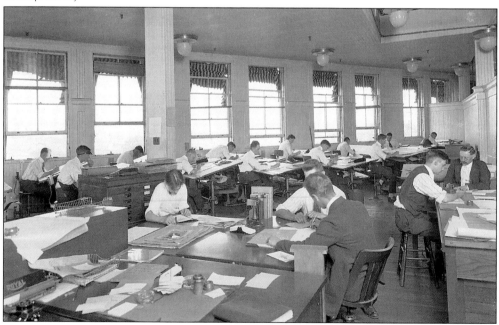

TOOL DESIGNING DIVISION OF NEW BRITAIN MACHINE CO. A new business was formed and incorporated when the J.T. Case Engine Co. was absorbed into the New Britain Machine Co. Noted industrialist Philip Corbin became the first president. Once located on Chestnut Street, the plant moved to South Street. Although New Britain Machine is no longer in the city, the factory buildings now house new industries. (Local History Room/NBPL.)

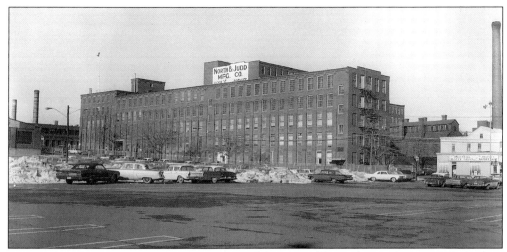

NORTH & JUDD MANUFACTURING CO. One of the city's oldest industries began in 1812, when Alvin and Seth North and Hezekiah Whipple began manufacturing small wire products. Items such as hooks and eyes, which were once made in the home, were soon manufactured at the factory. Lorin F. Judd bought an interest in the firm in 1855 and expanded his holdings in 1863, whereupon the company's named changed to North and Judd. The firm supplied the government with locally made wares during the Civil War and the two world wars. Gulf and Western eventually took over the corporation and yet another local industry disappeared. (Local History Room/NBPL.)

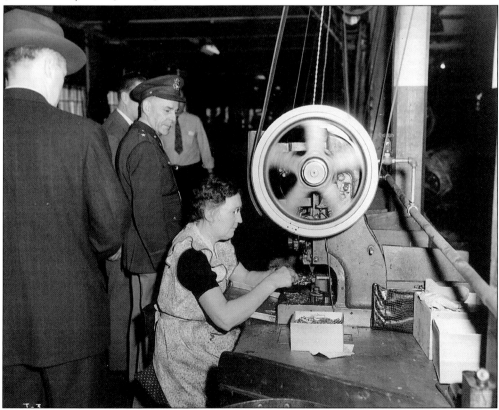

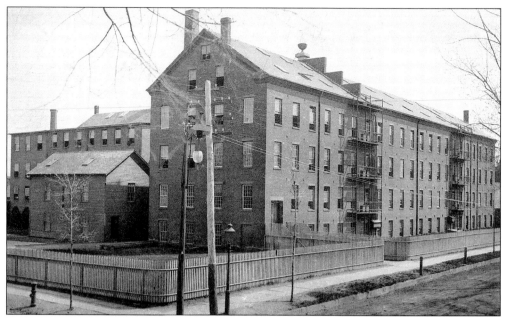

NEW BRITAIN KNITTING CO. Seth North became president of this industry, which was organized in 1848. In a town that was concerned primarily with hardware, it is worth noting that a textile industry thrived for many years. Fine garments for the entire family were produced here until it dissolved in 1905. (Local History Room/NBPL.)

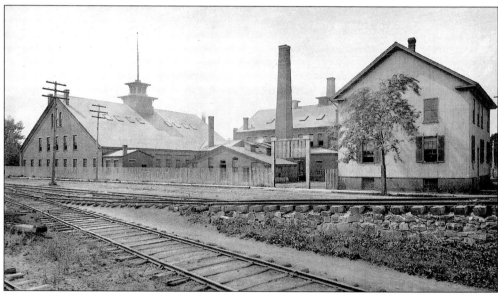

MALLEABLE IRON WORKS. Two iron work plants were once active in New Britain—Malleable and Vulcan. Both were absorbed by the Eastern Malleable Co. of Naugatuck, Connecticut. This building on Myrtle Street remained standing until 1974 ,when it was demolished for a parking lot. (Local History Room/NBPL.)

CORBIN SCREW CO. Some of the old factory buildings were purchased by other manufacturing concerns while others were simply razed. This photograph shows one of the giant generators used by the Corbin Screw Co. This is a good indication of the size of machinery found in factories throughout the city. (Fred Hedeler.)

NEW BRITAIN BANK & TRUST CO. New structures were not uncommon sights in the 1960s and 1970s. The New Britain Bank and Trust Co. was revolutionary in its shape and design. Today this building houses the ACMAT Corporation. (*Herald.*)

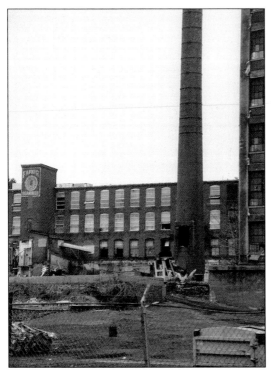

FAFNIR BEARING CO. One of the last remaining factories in the city was Fafnir Bearing. What started as a small endeavor in 1911 under the management of Elisha Cooper became an industrial giant. Fafnir suffered the same fate of many other local industries when it was taken over by a larger conglomerate. These two pages illustrate not only the demise of an industry, but also the death of its buildings. (James J. DaMico.)

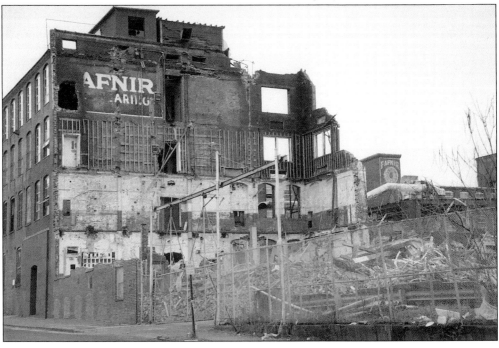

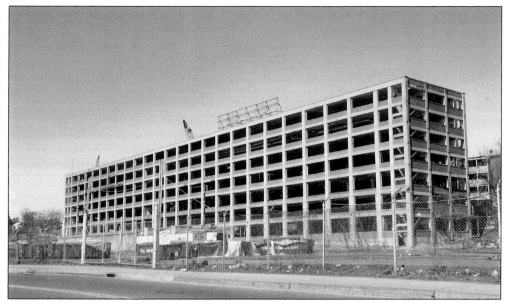

FAFNIR BEARING CO. While a film student at the Rochester Institute of Technology, New Britain native James DaMico decided to do his senior project on his hometown. His short documentary *Links in the Fence* is an interesting glimpse at the decline of industrialization in a New England city. DaMico, who is currently involved in film production, returned to document the razing of the Fafnir plant. Plans are in progress to use this site for a new business. (James J. DaMico.)

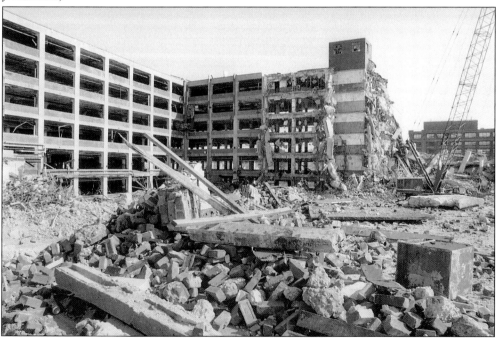

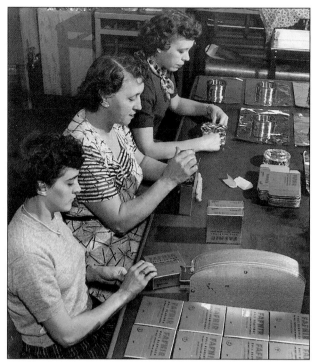

FAFNIR BEARING CO. Fafnir bearings were used in a wide variety of products. From airplanes and air conditioners to tractors and hand tools, the company's logo, the dragon, was recognized far and wide. Bearings and packaging are shown here being inspected. (Fred Hedeler.)

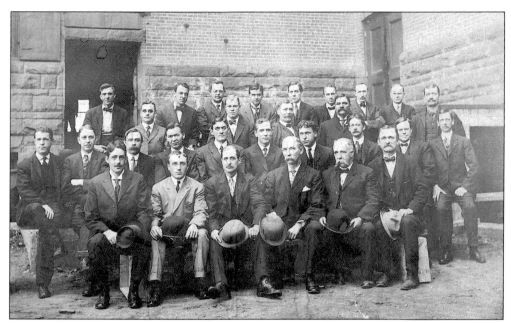

STANLEY WORKS EMPLOYEES, C. 1906. Of the city's old industries, Stanley Works is the only one that remains. From left to right are the following: (first row) Pfeiffer, Wagstaff, Lewis, Voight, Stevens, and Farmer; (second row) Loomis, Smith, Myers, Schoen, Truslow, Alan, Latham, Barsch, Wooster, Walter, and Bradley; (third row) Weed, Middleton, Leist, Paulson, and Wallen; (fourth row) Wall, Mervin, Porter, Parsons, Byer, English, English, and Meehan. (Local History Room/NBPL.)

HIGHWAY. Once the site of Lockshop Pond, the development of the highway changed the city forever. It runs parallel to Lake Street; Cedar Lake Clinic is visible on the left. (*Herald.*)

CW GROUP, INC.
There are active signs of revitalization, as shown by these before-and-after photographs. Originally part of Stanley Works, the building at 200 Myrtle Street was donated to CW in 1989 and now houses CW Resources and the Connecticut Enterprise Center. Combined aid from the city and state helped CW refurbish the building, which reopened in 1996. (Joan Rhinesmith/CW Group, Inc.)

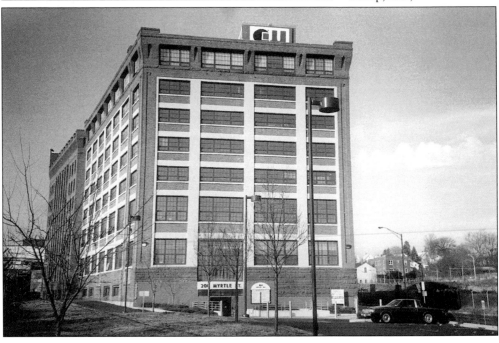

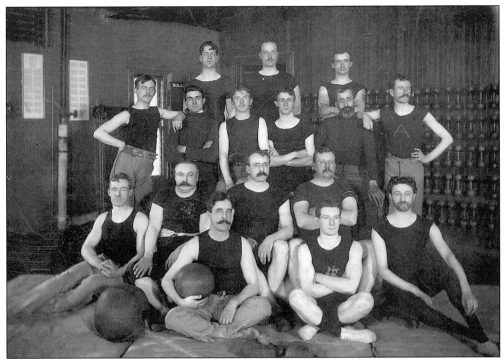

YMCA BUSINESSMEN'S CLASS. With New Britain's status as an industrial center, residents needed to not only work hard, but keep in shape. In 1900 the YMCA's business class paused for this portrait. (Local History Room/NBPL.)

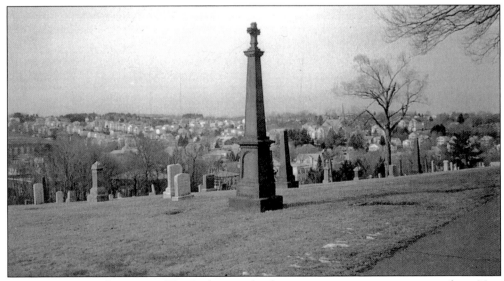

OLD ST. MARY'S CEMETERY. The Irish were the first major immigrant group to settle in New Britain. They were followed by numerous other ethnic groups that made up the work force in the city. When these first immigrants were laid to rest, they chose this spot on "Dublin Hill," overlooking what, at that time, would have been rolling hills, reminiscent of their homeland. (Dennis Morrell.)

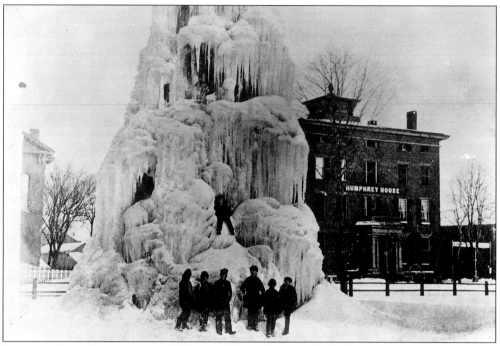

CENTRAL PARK FOUNTAIN, C. 1875, AND MAIN STREET, 1968. Every winter, before the Civil War monument was erected, an evergreen tree was placed in the fountain in Central Park. The water was turned on until a beautiful ice sculpture appeared, as pictured here. Behind it stands the Humphrey House; below is the east side of Main Street. The Card Shop and Brand Discount Store stood approximately where the Humphrey House was located. By 1999 most of these stores were gone and the face of Main Street changed yet again. (Local History Room/ NBPL/*Herald*.)

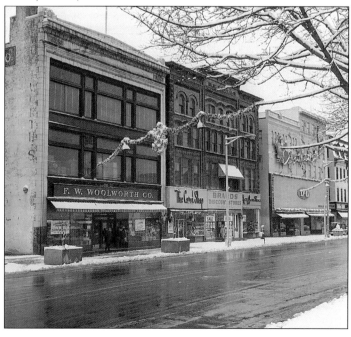

Four

IMPORTANCE OF THE BALL

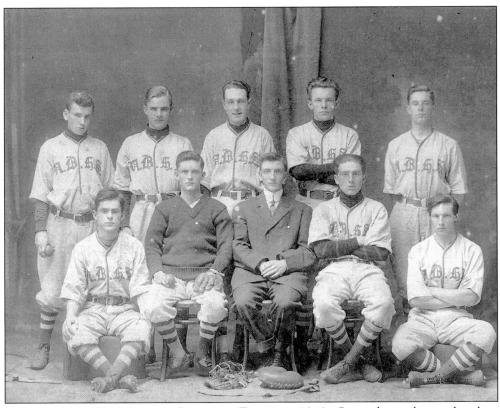

NEW BRITAIN HIGH SCHOOL BASEBALL TEAM, C. 1912. Sports have always played an important part in the lives of New Britain residents. From high school athletes, such as those pictured here, to the industrial leagues, to professional teams like the New Britain Rock Cats, sports have enriched the lives of residents both young and old. (Local History Room/NBPL.)

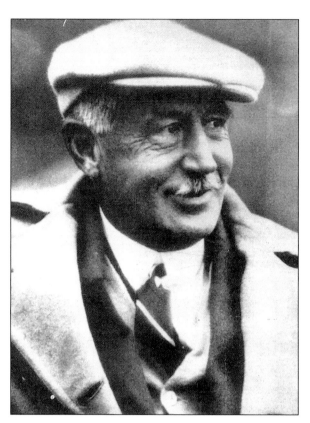

WALTER C. CAMP (1857–1925).
Of all the important sports figures, few can compare to the man called the "Father of American Football." New Britain native Camp, a Yale graduate who studied physiology and anatomy, is credited with establishing the rules of football. His advocacy of a "daily dozen" prompted hundreds across the country to exercise for improvement of mind and health. (Don Clerkin/ N.B. Sports Hall of Fame.)

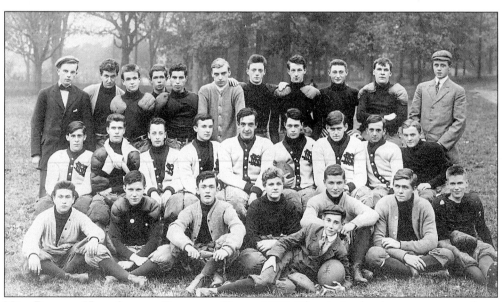

NEW BRITAIN HIGH SCHOOL FOOTBALL TEAM, 1908. The city's school sports programs have always been of high caliber. From coach "Chick Shea" to athletes like Willie Hall and, most recently, Tebucky Jones, football has provided the city with excitement and instilled pride in the community. (Local History Room/NBPL.)

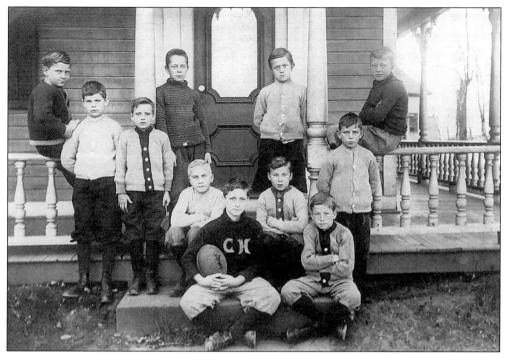

CHILDREN'S HOME FOOTBALL TEAM. Not all teams were formally organized. The Children's Home, now the Klingberg Family Center, provided a physical outlet for their young residents. They enjoyed the game while learning the importance of team play. (Klingberg Family Center.)

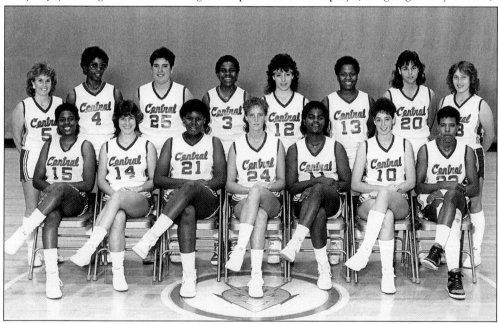

CENTRAL CONNECTICUT STATE UNIVERSITY WOMEN'S BASKETBALL TEAM. Many feel women's basketball has only recently emerged with the national coverage received by the UCONN ladies team. Many schools, however, have had women's teams participating in the sport, including these athletes from CCSU in 1986. (Herald.)

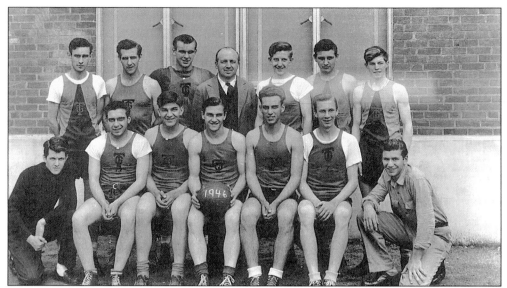

E.C. Goodwin Technical School Basketball Team. Nicknames often stick with a player long after their school days are over. Pictured in 1946, from left to right, are as follows: (front row) unidentified, Jack Papini, Henry Buckowski, Joe "YoYo" Sidik , James "Jazz" Boccuzzi, "Zipper" Dzioba, and Chet Rogala; (back row) Chet Rustic, Mathew Gut, "Jugger" Dzioba, Coach Waronecki, Larry Sowa, unidentified, and Emil Mosey. (James Boccuzzi.)

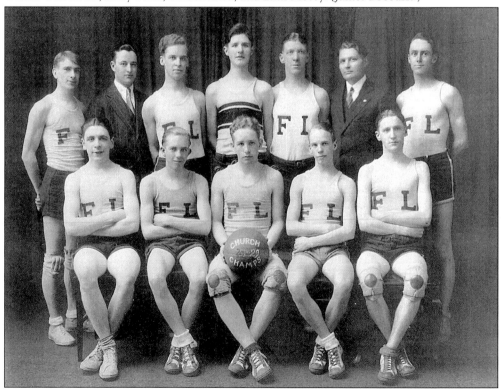

First Lutheran Church Champs. Not all basketball champs came from the schools. This team won the state championship for the 1928–29 season. (Susan Stein.)

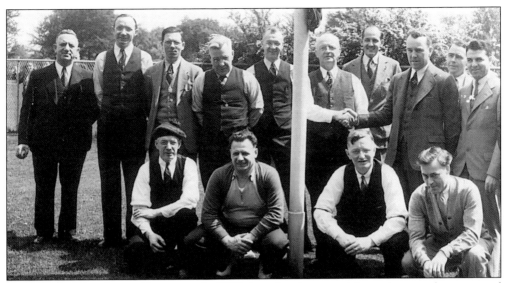

TAM O'SHANTER LAWN BOWLERS. In 1938 these bowlers posed for a photo as they accepted congratulations from the mayor. From left to right are as follows: (kneeling) James Patterson, George Unwin, Neil MacDougal, and Robert Brown; (standing) John Drummond, J. Rostrom, George Thompson, David Morrison, Robert Pattison, club president Thomas Spence, park commissioner Charles Ralph-Newton, Mayor Coyle, park commissioner Robert Hughes, and chair of the park board John Cianci. (*Herald*.)

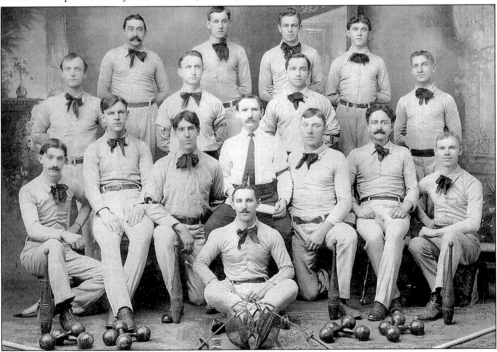

TURNER SOCIETY, C. 1910. On April 25, 1853, two local German societies merged forming "Sozieler Turnverein" (social Turner society), which was mainly concerned with keeping the body in shape through physical training. They built a new hall on Arch Street in 1871 and another on the same street in 1912. (Eleanor Z. Benson.)

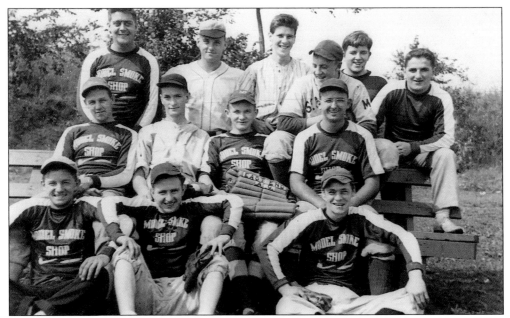

MODEL SMOKE SHOP TEAM, 1941. Located at 218 East Street, the smoke shop sponsored this senior city team in 1941. It was made up of friends who lived on the east side of the city. From left to right are as follows: (front row) Thomas Farrell, Louis Zotter, and John Noonan; (middle row) ? Terwilliger, Raymond Linn, Howard Kiley, and Joseph Bucko; (back row) John Nolan, Dick Barrows, Don Dixon, Donald Brause, George Poji, and Paul Sirianna. (Richard Barrows.)

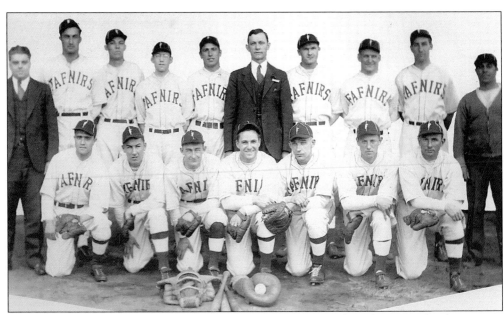

FAFNIR BASKETBALL TEAM, 1934. Factory work provided goods and services for the country and livelihoods for the employees. The teams that were part of the industrial leagues provided camaraderie. This team finished on an equal footing with Stanley Works—both had 11 wins and 4 losses. (Local History Room/NBPL.)

Five

Taking Care of
Business

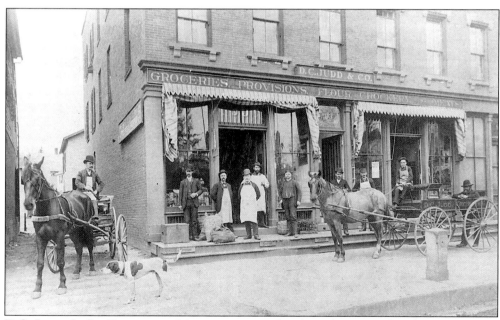

D.C. Judd & Co. Employees. Many immigrants found employment other than in factories. With hundreds pouring into the city each year, the need for food and clothing stores increased. Dwight C. Judd stands among his employees, including German-born Emil Hagist, who mans the delivery wagon. Judd ran stores in two locations, at 246 Main Street and the one shown here at 93 Arch Street. (G. Paul Hagist.)

MAX HONEYMAN/PACKARD DEALER.
Dapper and debonair, Max Honeyman
appears below in one of his automobiles.
One of the city's earliest car dealers,
Honeyman first dealt in Hudsons and
then became the sole distributor of
Packards in the early 1920s. He inspired
members of his family to join him in
business. He also built the Packard
Building, which remains standing on
the corner of Arch and Walnut Streets.
(Steve Sicklick.)

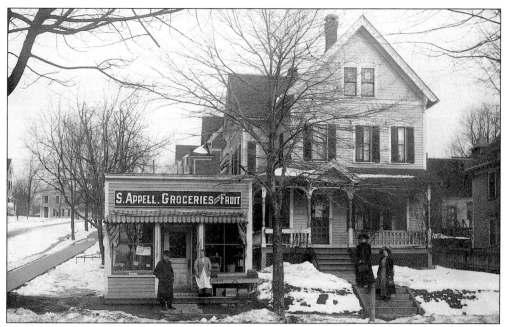

S. Appell Grocery Store. Small neighborhood businesses thrived in the early to middle part of the 20th century. Solomon Appell emigrated from Russia to Colchester. After a return visit to his homeland he brought his family to New Britain, where he started a grocery business. His son Morris worked in the family store until he went into business with his sister Luba. (Local History Room/NBPL.)

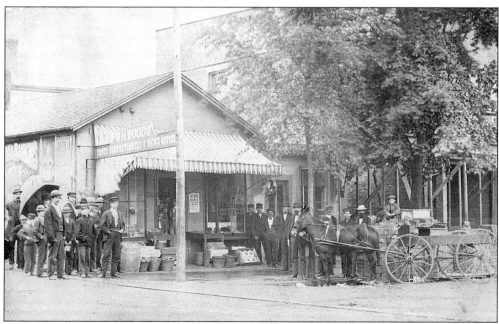

S.H. Woods and Employees. The railroad tracks in the foreground confirm that Woods' store was located on the west side of Main Street, just north of the tracks. The fruit, confectionery, and news dealer was only in business during the 1870s. (Local History Room/NBPL.)

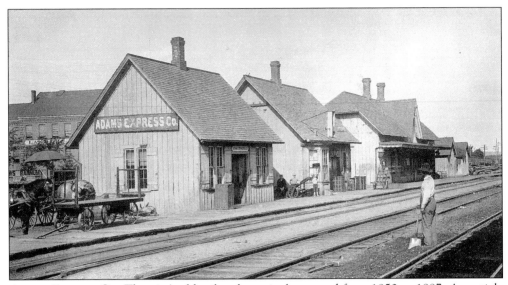

ADAMS EXPRESS CO. The city's old railroad terminal operated from 1850 to 1887. An article from the *Observer* of October 1, 1887, stated, "The old wreck of a building which for so many years we have been forced to recognize as our passenger station is no more." (Local History Room/NBPL.)

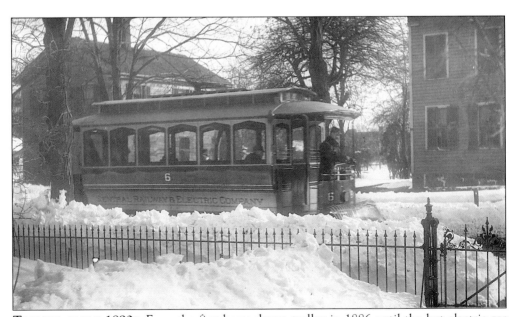

TROLLEY, EARLY 1890S. From the first horse-drawn trolley in 1886 until the last electric car ran in 1937, trolleys provided an interesting means to get about the area. This one is running past 218 Chestnut Street. (Marie Venberg.)

C.H. WILLIAMSON. Born the year New Britain incorporated as a city in 1871, Cornelius Howard Williamson Sr. ran a prosperous paint and framing establishment at 626 Main Street. (Phoebe Lucille Bomer.)

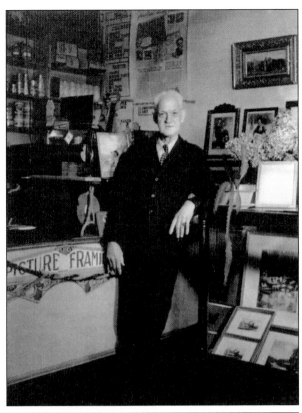

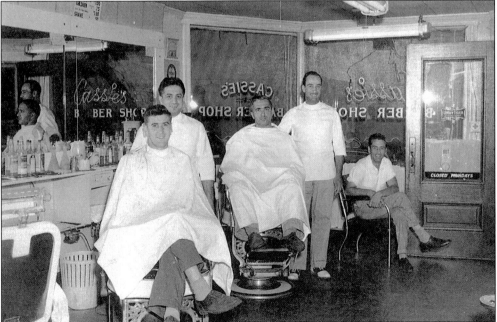

CASSIE'S BARBER SHOP Long before men frequented stylists, barbershops offered hair cuts for $1 and shaves for 50¢. On the far left, Jack Fussari awaits Nick Arena's scissors. In the middle, Cas Cosina prepares to give a customer a trim as Tony Dinoia looks on. (Cas Cosina.)

CAPITOL LUNCH. Ask anyone in the country who has been affiliated with New Britain and they will all probably tell you about Capitol Lunch! The locations have changed, from the corner of North and Willow Streets, to the corner of North and Hartford Avenue, seen above. It was called Oxford Lunch then. Yet another move (pictured below in the late 1930s) brought the business to its current Main Street location. Owner Peter Lampros confers with employee John Colevas. The site may have changed but the famous sauce for the hot dogs has not. (Nicholas Lampros.)

SANDELLI FLORIST. Adolfo Sandelli was often called "King of the Poinsettia." He established his business in 1912 and incorporated it in 1947. For years the Sandelli family maintained a dozen greenhouses in the midst of residential Oak Street. People from throughout the area flocked to Sandelli's for their exquisite Calla lilies, poinsettias, and hundreds of other flowers. Although the business is gone, the site will soon be in use again as Urban Oaks, a community and cooperative garden. (Rosemary Agostinucci.)

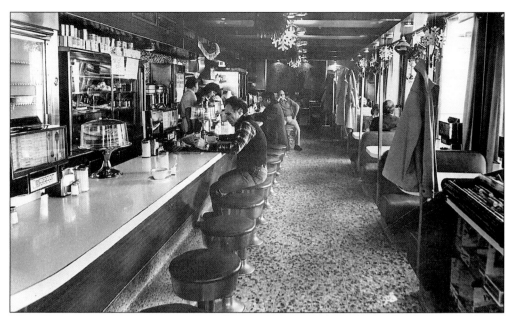

MISS WASHINGTON DINER. Located in what was once a residential area, this diner is the last of its kind in the city. Open 24 hours a day, 7 days a week, 365 days a year, it is the one spot that never turns away a body in need of coffee or sustenance. (George Georgiadis.)

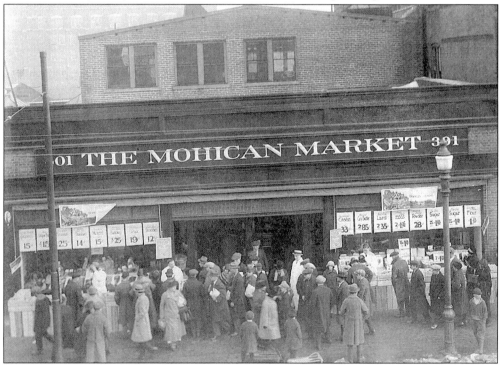

MOHICAN MARKET. With the increase in population, it was inevitable that larger markets would develop. Mohican may not have been the size of the super stores of modern times, but the establishment carried a wide variety of wares and had an ambiance unsurpassed today. (Charles J. Sullivan.)

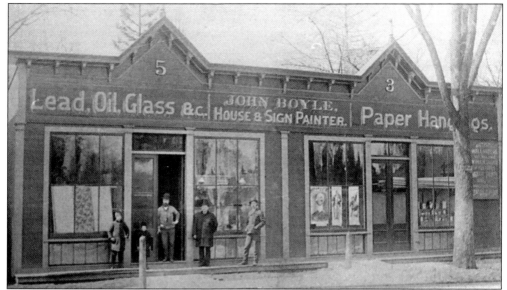

JOHN BOYLE CO. Originally located at #3 and #5 Franklin Square, Boyle's paint and wallpaper business endured the Great Depression, fire, location changes, and new owners. The business opened in 1878, and now—121 years later—it is still going strong! (*Herald.*)

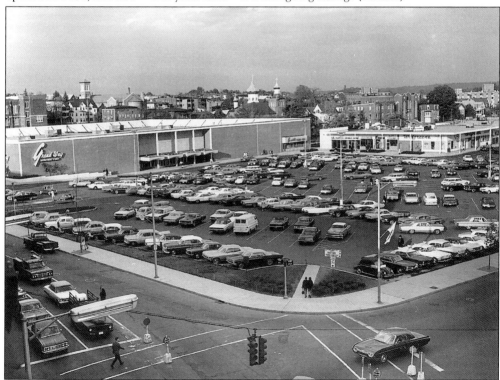

NEWBRITE PLAZA, 1967. With malls and shopping centers replacing "mom and pop" stores, Newbrite Plaza was on the cutting edge of the retail trade. Flanked on one end by the Grandway Department. Store and on the other by Grand Union, the plaza offered one-stop shopping. (Local History Room/NBPL.)

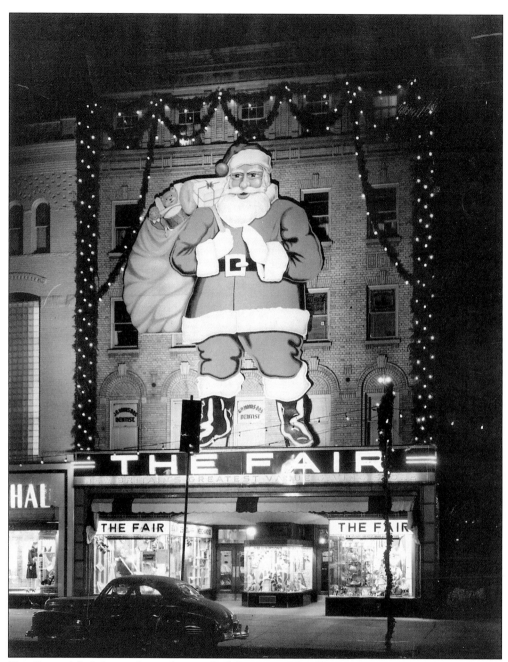

THE FAIR. A holiday tradition that marked the start of the Christmas season was the placement of the giant Santa on the Fair. This store epitomized an era when family businesses were booming and stores lined the entire length of Main Street. Long before the emergence of impersonal department stores and malls in the area, owners like Davidson and Leventhal knew many of their clientele personally. (Herald.)

Six

PICTURE THIS!

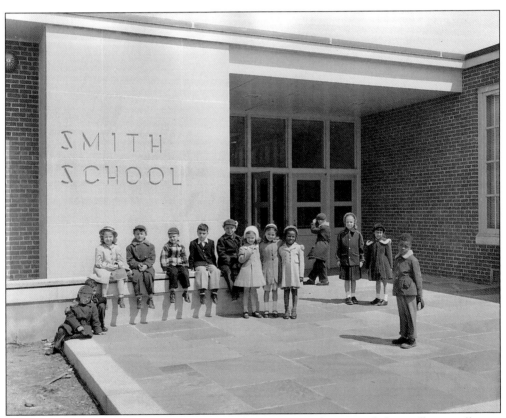

SMITH SCHOOL, 1953. The development of a society is often recorded visually as well as in print. Photographers' archives burst with images of joy, sorrow, and everyday occurrences. One of New Britain's finest photographers, Charles J. Sullivan, was not a native of the city. He was born in Westerly, Rhode Island, and moved here as a child. This chapter illustrates some of his views of New Britain. The photograph above simply shows us the innocence and acceptance of children. (Charles J. Sullivan.)

FIRST STUDIO. Charles Sullivan's first studio was located at 140 Main Street. The building was later damaged by fire and razed. McDonald's was built on this site, but it too was demolished. The area is now a parking lot. (Charles J. Sullivan.)

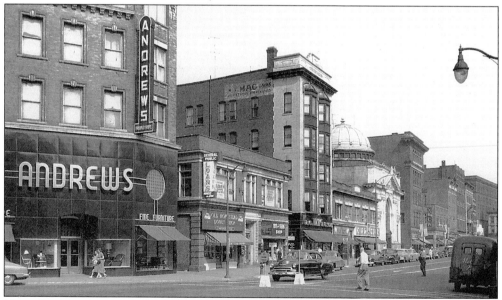

MAIN STREET, 1953. The building that housed Sullivan's studio was dwarfed by the Andrews Furniture Store and the old Mag's. Main Street was booming during this era and the architecture, much of which is now gone, featured elaborate, ornate details. (Charles J. Sullivan.)

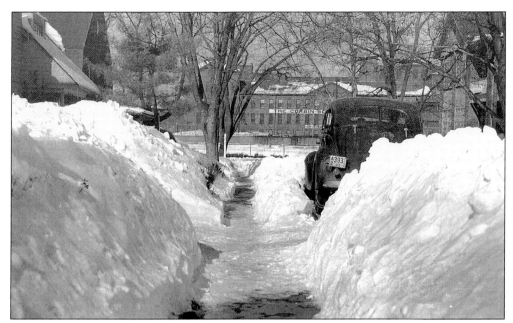

LAKE COURT. The photographer lived on one of the shortest streets in the city. Lake Court, between Cedar and High Streets (now the YMCA parking lot), held less than a dozen houses. In January 1948 the city was hit by a typical New England storm. In the distance stands the old Corbin Screw Co. (Charles J. Sullivan.)

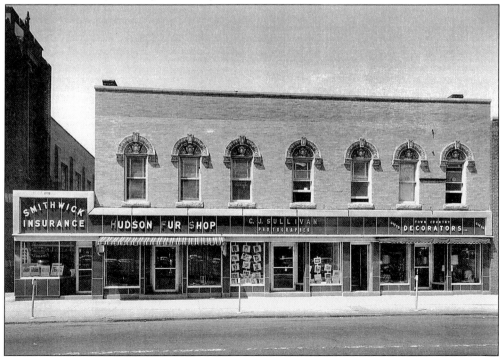

FRANKLIN SQUARE. Sullivan's studio was moved from lower Main Street to 11 Franklin Square. The Southwick Insurance Co. remains in this building, but the other businesses are gone. (Charles J. Sullivan.)

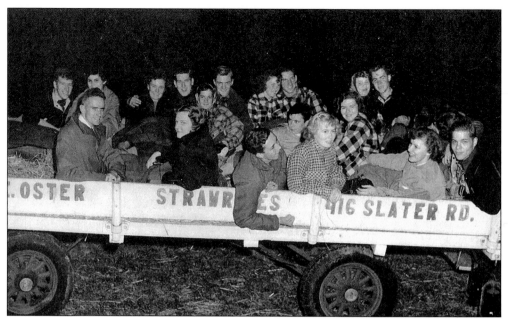

HAYRIDE. Charles Sullivan devoted much of his spare time to working with young people. Whether the organization was DeMolay, the YMCA Cavaliers, or a group participating in a hayride, he was on hand to help out. He is pictured here in 1949 with a group enjoying a November outing. (Charles J. Sullivan.)

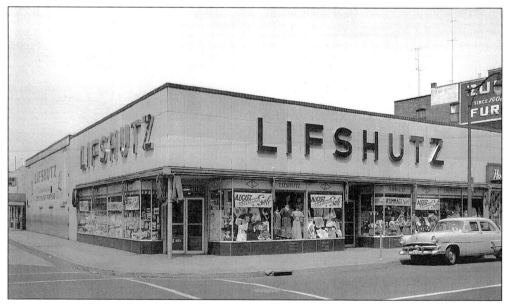

LIFSCHUTZ. Although the photograph was taken 43 years ago, the memory of Lifschutz lingers in people's minds as if it was still open for business. Sullivan's image captures the eye-catching window displays and the allure of the end-of-the-summer sales. (Charles J. Sullivan.)

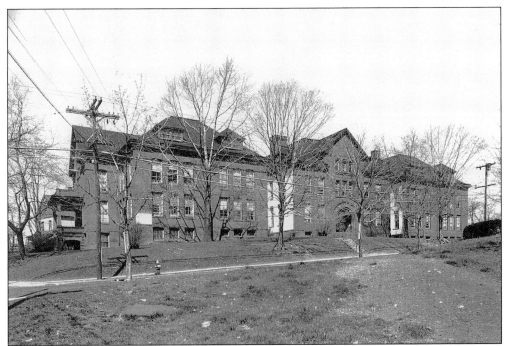

CHAMBERLAIN SCHOOL AND STANLEY TOOLS. Many of the city's buildings were recorded by Sullivan. The old Chamberlain School, located between Woodland and Dwight Streets in 1953, now has a new face. This last look at the old Stanley factory was taken before urban renewal called for its demise. Many of the city's old buildings survive only on film. (Charles J. Sullivan.)

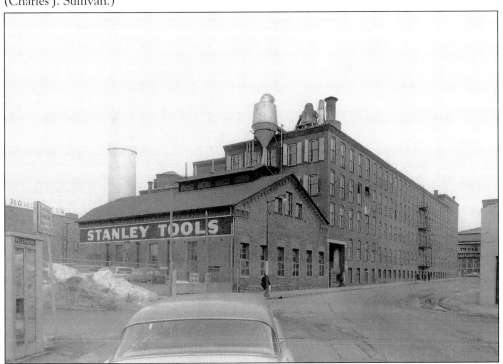

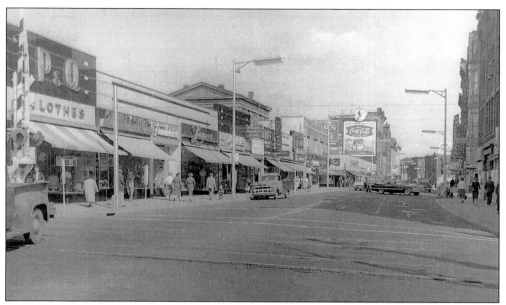

MAIN STREET, 1960. The long, main thoroughfare of the city ran from McCabe Park in the north all the way down to Franklin Square. Just north of the railroad tracks was the portion featured here, which housed clothiers, bakeries, package stores, theaters, and furniture stores, none of which survive today. (Charles J. Sullivan.)

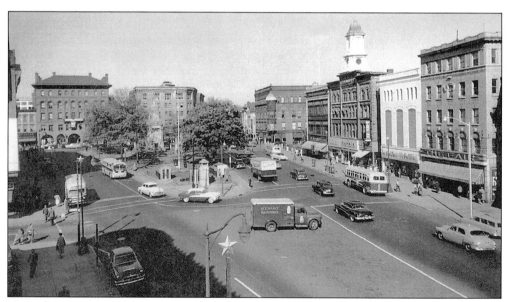

MAIN STREET, 1956. The mid-section of Main Street is located right in the heart of the city. City hall, the New Britain Trust Co., old First Church, and a bevy of retailers flank Central Park. The comfort stations that were later closed and filled in are still visible in Sullivan's photo. (Charles J. Sullivan.)

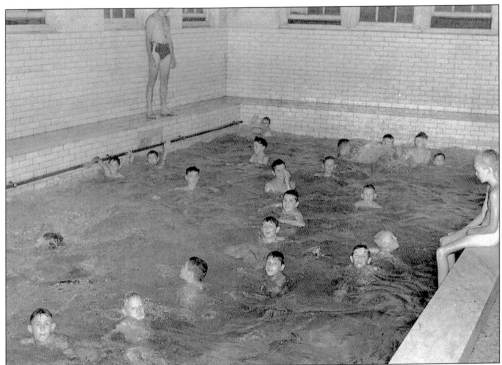

YMCA, 1948. Before moving to its new building on High Street in 1954, the YMCA was a fixture downtown. Many a lad remembers the pool and no co-ed participation that allowed for the occasional skinny-dip! (Charles J. Sullivan.)

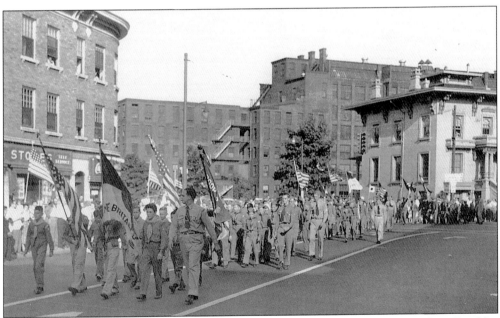

BOY SCOUTS, MAY 31, 1954. The Memorial Day parade came up Main Street from Franklin Square. Scouting offered boys of all ages opportunities to learn new interests, develop friendships, and become responsible, active participants in the community. (Charles J. Sullivan.)

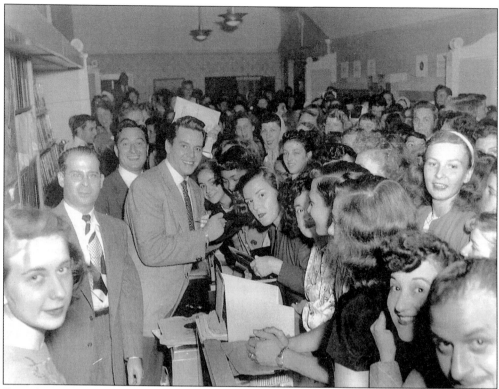

DESI ARNAZ, 1947. Many famous celebrities have visited New Britain, from Buffalo Bill Cody to Vice President Al Gore. Residents turn out in throngs to greet well-known personalities. Sullivan captures the enthusiasm of old and young alike as Desi Arnaz signs autographs. (Charles J. Sullivan.)

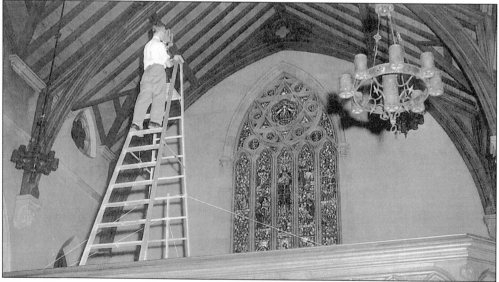

SOUTH CONGREGATIONAL CHURCH. Some jobs call for a photographer to go the extra step for the perfect shot. In April 1953, Sullivan balanced precariously on an oversized ladder in the choir loft to capture the beauty of a stained-glass window. (Charles J. Sullivan.)

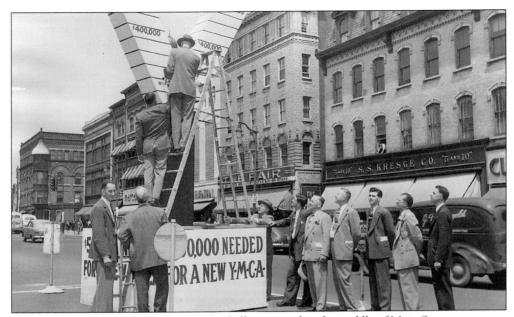

YMCA FUND DRIVE. On May 16, 1951, Sullivan stood in the middle of Main Street to capture this moment for posterity. The event didn't stop traffic on the east side of the street, but did draw the attention of a citizen on the second floor of Kresge's. (Charles J. Sullivan.)

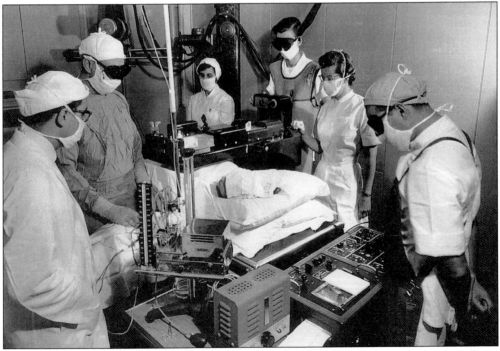

NEW BRITAIN GENERAL HOSPITAL. Asked to record a drill for a serious operation, Sullivan caught the staff at work in December 1953. The importance of the hospital is never more apparent than today as it celebrates its 100th birthday. In a city that was founded on industry, it is interesting to note that NBGH is now the largest employer in the community, confirming New Britain's commitment to people over products. (Charles J. Sullivan.)

YMCA, MAIN STREET, JULY 29, 1950. Charles J. Sullivan was in the photography business from January 1946 until 1997. He took photographs while in the service and continued his studies thereafter in commercial, portrait, and direct color photography. His business cards stated, "Photography tells a story." That statement holds true by looking at this image, which sums up New Britain. The building was elaborate, downtown was thriving, and everyone seemed to have a purpose in where they were going. Although retired, Sullivan continues to view his city with an artistic eye. (Charles J. Sullivan.)

Seven

DARK DAYS

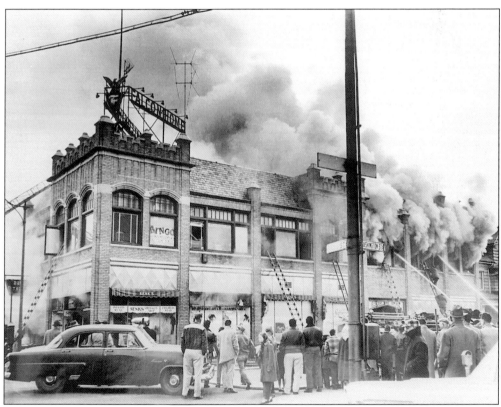

FALCON BUILDING FIRE, 1957. Anniversaries are times to look back, reflect on what has past, and ponder what is to come. As with all cities, New Britain has seen dark days; in the interest of history, painful events need to be recalled to balance happier times. The Falcon Building fire on the corner of Washington and Broad Streets drew crowds of spectators. (Robert J. McCran.)

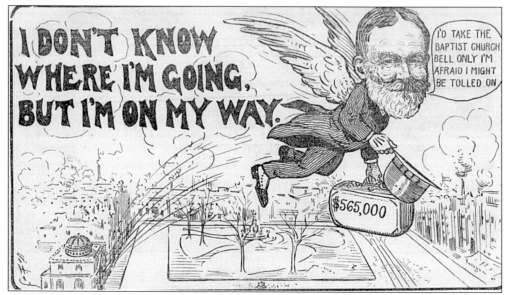

WILLIAM WALKER. Often we romanticize scoundrels and their deeds, but Walker's crime of deceiving those who trusted him and running off with half a million dollars was nothing to smile about. The chase across the country, his capture, and his refusal to reveal what happened to the money is one of the city's great mysteries. (Local History Room/NBPL.)

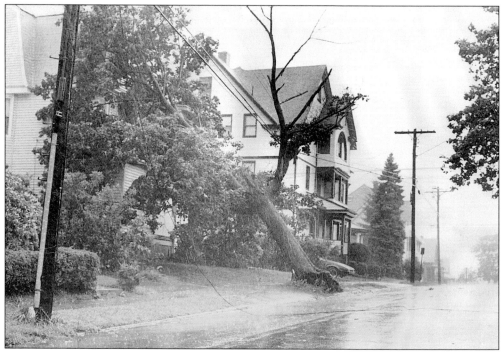

HURRICANE GLORIA. Natural disasters show little mercy for anything in their path. In 1985 this hurricane left trees uprooted, windows shattered, and power outages statewide. (*Herald.*)

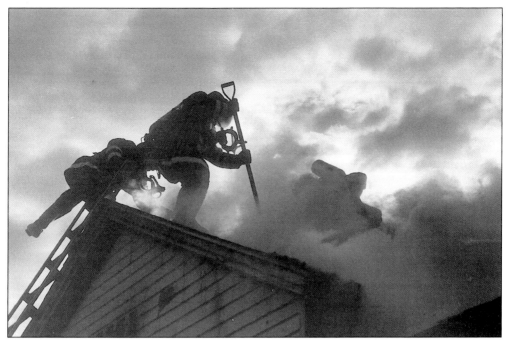

CLARK STREET FIRE. On March 3, 1989, *Herald* photographer Alan Chaniewski captured a dramatic moment on film. As one of the oldest houses in the neighborhood burned, local firefighters tried desperately to save the aging structure located on "Dublin Hill." (*Herald.*)

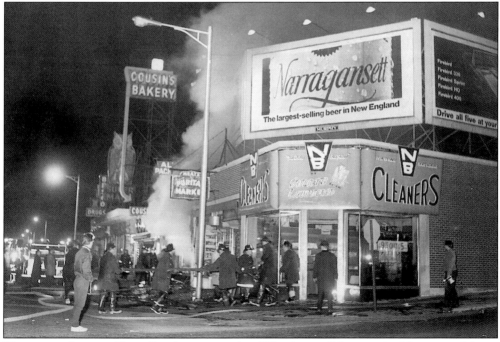

HARTFORD AVENUE FIRE. Residents remember "The Avenue" for its colorful variety of shops. In April 1967, fire broke out near Cousin's Bakery and the Puritan Market. A decade later, all of these storefronts disappeared and were replaced with housing. (*Herald.*)

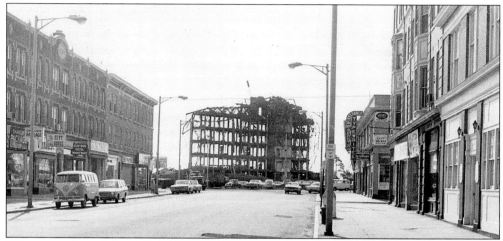

"NIGHT OF FIRES." In 1916 the National Militia was called out to protect the city as parts of it burned. In 1971 an eerie feeling once again permeated the city when American Hardware and other businesses burned. The view down Main Street is a grim reminder that much of New Britain could have been destroyed, had the fire not been contained. (*Herald.*)

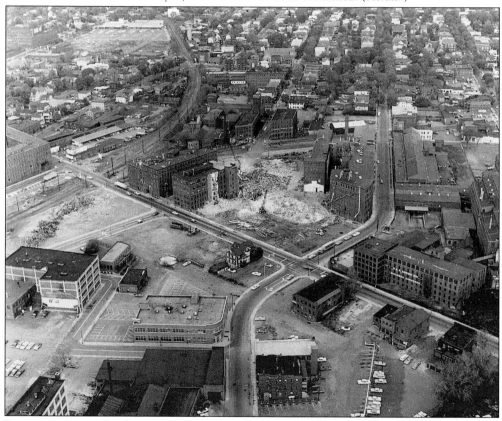

REDEVELOPMENT. In the mid-1960s and early 1970s, urban renewal was highly advocated throughout the country. New Britain saw its downtown district radically changed. Factories were sold, the highway split the city in two, and old buildings were razed, making way for a more modern look. (Local History Room/NBPL.)

Ku Klux Klan. In 1983 Klan members planned several rallies throughout the state, including this one in New Britain. The media deemed it a "non-event" as residents showed little interest. (*Herald.*)

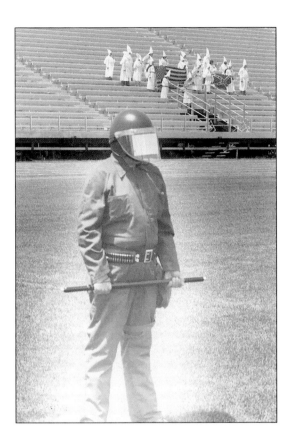

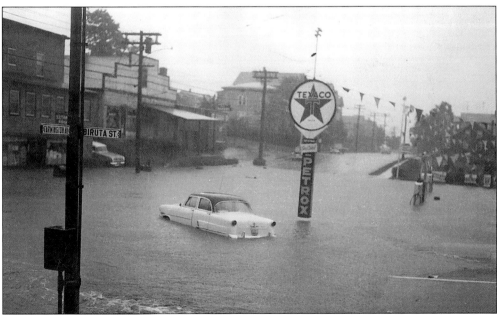

Flood of 1955. Fires have plagued the city for years, but the south end of the city has had the additional problem of frequent flooding. The 1955 flood devastated cities in the state and caused a fair amount of damage in New Britain. (*Herald.*)

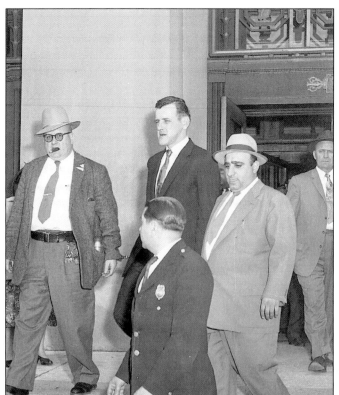

"Mad Dog Murders." Residents in the state were terrorized in the mid-1950s when a series of robberies and murders were committed. In December 1956 a gasoline station owner on Stanley Street and his customer were killed. Joseph Taborsky of Brooklyn, pictured above, and his accomplice, Arthur Culombe of Hartford, pictured below, were convicted. Dubbed the "Mad Dog Killers," both were sentenced to death. Culombe escaped the death penalty by appealing to the Supreme Court. Taborsky first appealed his sentence and later withdrew it. Taborsky was the last person to be executed in the state of Connecticut. (*Herald.*)

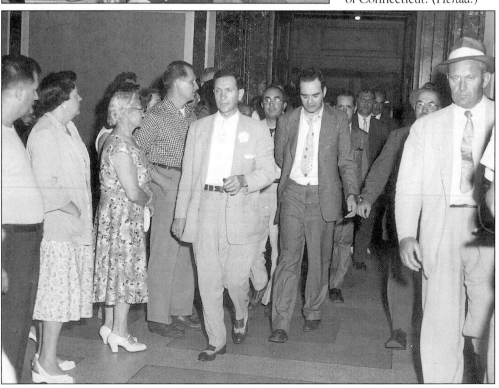

Eight

THOSE WHO LED US
PART II

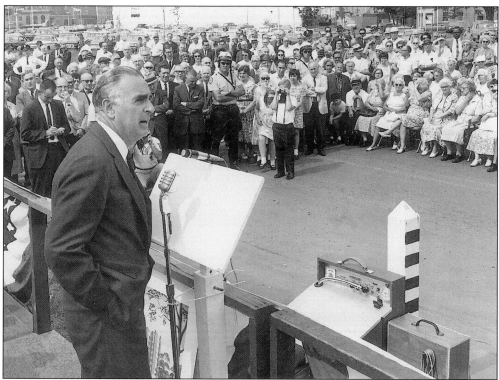

ABRAHAM RIBICOFF. Senator Ribicoff (at the microphone) speaks at the dedication of the Ribicoff Apartments for the Elderly in August 1967. One of two New Britain natives to become governor of Connecticut, Ribicoff also held the positions of judge, U.S. representative, senator, and secretary of health, education, and welfare under President Kennedy. Ribicoff, like the mayors on the following pages, worked diligently to improve the lives of residents. (Local History Room/NBPL.)

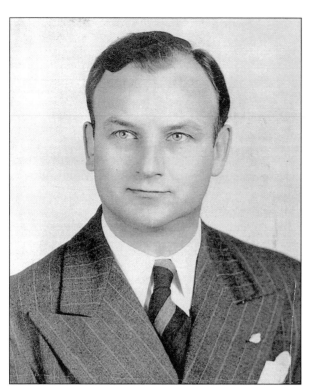

HENRY J. GWIAZDA, DEMOCRAT. World War II veteran Gwiazda is believed to have been the first Polish mayor in the state (1946–50). He graduated from Williston Academy, Wesleyan University, and the UCONN School of Law. He also served as a judge for New Britain's police, city, and probate courts. (City of New Britain.)

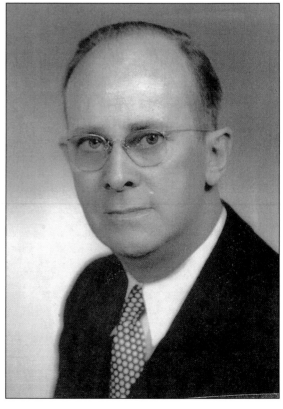

JOHN L. SULLIVAN, DEMOCRAT. One of the city's most colorful mayors (1950–54), John L., as he was known to many, devoted much of his life to politics. Although an accomplished musician, Sullivan decided to follow in his father's footsteps and enter politics. In addition to serving as mayor, he was a state senator and spent 16 years on the state tax commission. (City of New Britain.)

EDWARD B. SCOTT, REPUBLICAN. A New Hampshire native and a descendent of Benjamin Franklin, Scott graduated from Princeton and the Harvard School of Law. He served in the U.S. Navy during World War II and rose to the rank of lieutenant commander. His community activities were numerous, and included several years as mayor of New Britain (1954–56). To all who knew him, he was a "gentleman's gentleman." (City of New Britain.)

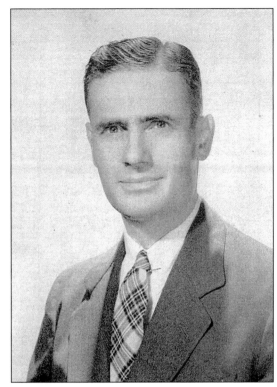

JOSEPH F. MORELLI, DEMOCRAT. The city's second mayor of Italian descent (1956–60) was born here and served in the U.S. Army during World War II. A graduate of the UCONN School of Law, he returned to New Britain to practice and to enter the political world. He served in the General Assembly and on the Board of Immigration Appeals. An active participant in local organizations, he was also a judge. (City of New Britain.)

JULIUS KREMSKI, DEMOCRAT. This Collinsville native held numerous public offices in addition to serving as mayor (1960–62). He chaired the Mattabassett District Commission, the New Britain Solicitations Board, and was a judge in the state's court of common pleas. During World War II, he served in the U.S. Navy on the destroyer *Grayson*. His work with Polish civic and social organizations and the veterans' service is recognized by all. (City of New Britain.)

THOMAS J. MESKILL, REPUBLICAN. Meskill served for several years as mayor of New Britain (1962–64), and was the second New Britain native to become governor of Connecticut. He attended local schools and later graduated from Trinity College and the UCONN Law School. His public service contributions include serving as the city's corporation counsel and as U.S. representative from the sixth district. Having worked on a tobacco farm as a mailman and a buffer, Meskill understood the plight of the working man. (City of New Britain.)

JAMES F. DAWSON, DEMOCRAT. An attorney for the state tax department, Dawson also served as legal counsel for the City Improvement Commission and as mayor of New Britain for a short time (1964–65). He was responsible for the expansion of the city's recreation facilities. New Britain mourned his loss in 1986, when his boat was lost off Cape Cod. (City of New Britain.)

PAUL J. MANAFORT, REPUBLICAN. There are few city boards upon which Manafort has not held a position. A veteran of World War II, he has been active in veteran organizations as well as innumerable church, civic, and social associations. Although involved with the family business for over 30 years, he still found time to serve in both city and state government, including several years as mayor of New Britain (1965–71). (City of New Britain.)

ALGERT F. POLITIS, REPUBLICAN.
New Britain's 30th mayor (1971)
graduated from local schools and
Fordham University. Community
minded, he worked closely with the
Diocesan Bureau of Social Services,
Catholic Family Services, the
YMCA, and the Community Chest.
He excelled in sports and won an
honorable mention for the Heisman
Trophy. During World War II, he
was employed by the FBI. (City of
New Britain.)

STANLEY J. PAC, DEMOCRAT.
Pac served in the Marine Corps
during World War II and returned
home, where he would serve
as a state representative, state
senator, and mayor of New Britain
(1971–75). The former motor
vehicle commissioner left the
office of mayor to become the
head of the state department of
environmental protection. (City
of New Britain.)

JAMES J. CAREY, DEMOCRAT.
Unlike many other mayors,
Yale-graduate Carey brought a
strong background in education
to the city's top position. After
ten years of teaching, he became
an administrator as principal in
the school system and held that
position in three different schools
from 1960 to 1982. During that
time he served briefly as New
Britain's mayor (1975). (City of
New Britain.)

MATTHEW J. AVITABLE, DEMOCRAT.
Public service has played a big part in
Avitable's life. A graduate of Cornell
and the UCONN School of Law, he
participated in city campaigns and chaired
the Charter Revision Commission in 1949.
He served as clerk of circuit court #15 for
12 years, and was also a city alderman, state
senator, and mayor of New Britain (1975–
77). (City of New Britain.)

WILLIAM J. McNAMARA, DEMOCRAT. As the mayor who held that position for the most consecutive terms (six, 1977–89), McNamara's commitment to his city is unquestioned. A graduate of Michigan State and the University of Hartford, he has held a number of public positions. From police officer to teacher to advocate of veterans' affairs, McNamara's top priority has been to improve life for all city residents. (City of New Britain.)

DONALD J. DeFRONZO, DEMOCRAT. Backing the working man sustained DeFronzo during his terms as mayor (1989–93). He served as president of a state employees' union and planning analyst for the state office of policy and management. A graduate of Fairfield University and UCONN, his contributions on the local and state level are innumerable. (City of New Britain.)

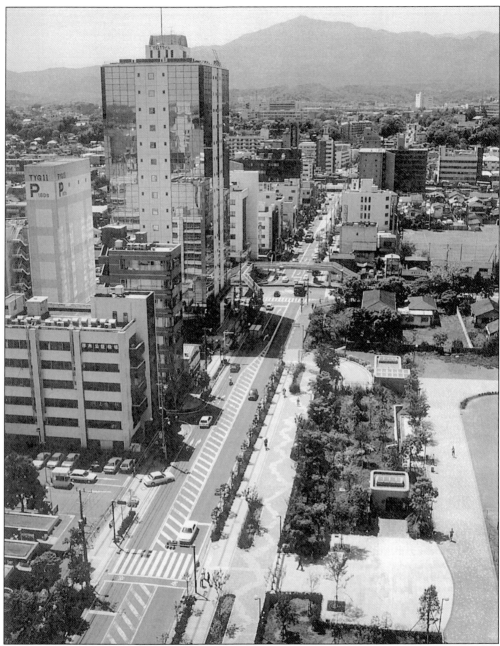

ATSUGI, JAPAN. In 1983, Mayor William J. McNamara and Mayor Shigenori Adachihara signed an agreement forming the first sister-city bond between New Britain and a foreign nation. In addition to Atsugi, we have sister-city relationships with Rastatt, Germany, Pultusk, Poland, Priolo, and Solarino, Italy. Exchanges with our sister-cities range from educational to cultural. One of the city's most famous native sons, Elihu Burritt, a peace advocate recognized world-wide, organized the League of Universal Brotherhood back in the mid-19th century. As we near the new millennium, it is encouraging to note that Burritt's concept of a unified common man or brotherhood continues to flourish through sister-city relationships. (Deborah Pfeiffenberger/ Youth Museum.)

LINDA A. BLOGOSLAWSKI (MYLNARCZYK), REPUBLICAN. History was truly made when Blogoslawkski became the first woman mayor of the city (1993–95). A New Britain native, she graduated from local schools and Fairfield University. Part of her college education was spent at the Catholic University of Lublin, Poland, where she studied her Polish heritage. Citizens of New Britain were grief-stricken when her life ended tragically in 1998. (City of New Britain.)

LUCIAN J. PAWLAK, DEMOCRAT. Belgian born, the current mayor (1995–99) personifies the "American dream come true." He immigrated to this country in 1957. Locally educated, he excelled in football and track and field, and received a scholarship to Wichita State University. His activities in local government extend from city treasurer and town/city clerk to his present position. He has been, and remains, involved in numerous civic and community organizations. (City of New Britain.)

DOROTHEA WHITNEY RICHARDSON. An activist for women's rights, Richardson's community involvement knew no bounds. Whether marching with suffragettes in 1915 or presiding over local chapters of the League of Women Voters and the College Club, she worked tirelessly for the betterment of women everywhere. (Fran Richardson Brautigam.)

PAST MAYORS. This is a rare gathering of nine former mayors. Pictured, from left to right, are as follows: (seated) Ed Scott, George Coyle, and Joe Halloran; (standing) Julius Kremski, John L. Sullivan, Henry Gwiazda, Algert Politis, Joseph Morelli, and James Dawson. (Local History Room/NBPL.)

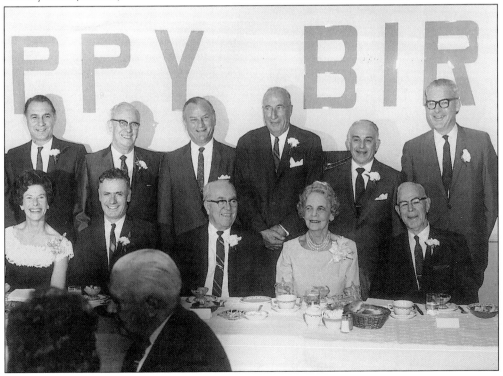

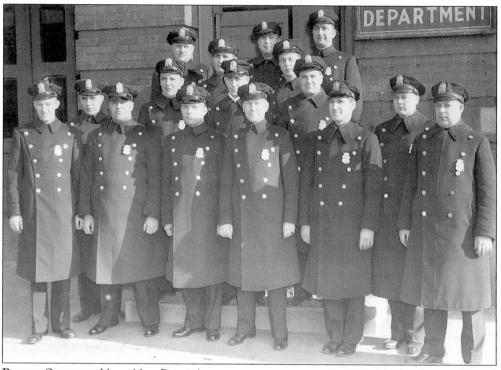

POLICE OFFICERS. Upon New Britain's incorporation as a city in 1870–71, the charter allowed for the appointment of a police captain and three active patrolmen. Uniforms today differ from those worn in this picture taken on Commercial Street, but the task of protecting New Britain's citizens has remained the same. (Ernest Horvath.)

FIRE DEPARTMENT C. 1860. Early firefighters were volunteers. It was not until the early 1870s that a salaried department was established. This photo depicts four of those early volunteers: Boardman, Copley, Seward, and Bostwich. (Local History Room/NBPL—Copley Estate.)

Nine

GRAND AND GLORIOUS

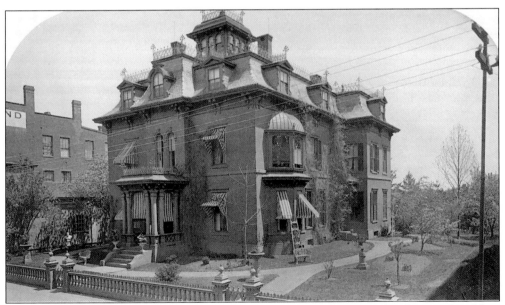

LORIN F. JUDD RESIDENCE. Main Street at the end of the 19th century hardly resembles Main Street today. This residence was located next to the Strickland House (later to become the Hotel Sarsfield) near East Main Street. Judd, a New Britain native, was born in 1820 and was one of the founding fathers of H.F. North and Co., which evolved into the North and Judd Manufacturing Co. He was active in community affairs, holding directorships in the New Britain National Bank, the Gas Co., the Tramway Co., and Union Manufacturing, among others. His money was invested solely in New Britain concerns. Judd died here at his palatial home in downtown New Britain. (Local History Room/NBPL.)

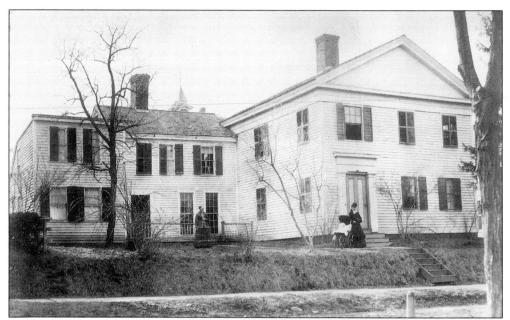

ABIJAH FLAGG RESIDENCE. This home, built by Enos A. Smith c. 1830, was sold to Abijah Flagg in 1840. Located at 25 South High Street, it is reputedly the oldest home in the downtown area. Flagg, a cabinetmaker, founded a furniture store that later became B.C. Porter & Sons. Here Cornelia Flagg Middlemass pushes her daughter Agnes in the carriage. (Local History Room/NBPL.)

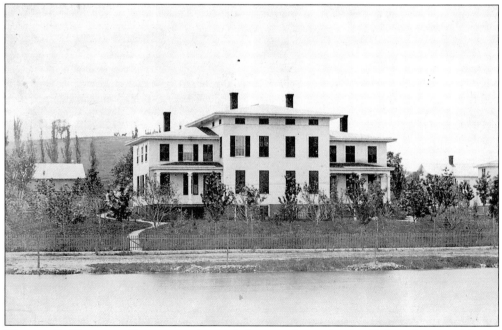

WILLIAM L. HUMASON RESIDENCE. A noted photographer and artist, Nelson Augustus Moore, captured the rural setting of the Humason House, which once stood on Cedar Street. The Lockshop Pond is in the foreground and part of Walnut Hill Park is visible in the distance. (Local History Room/NBPL.)

102

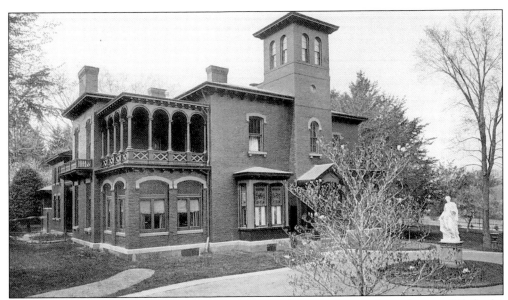

Henry Russell Residence. Grove Hill was once the site of magnificent homes. While the Whittlesey and Wesoly mansions remain, "The Grove," industrialist Henry Russell's home, was taken down to make way for the highway. (Local History Room/NBPL.)

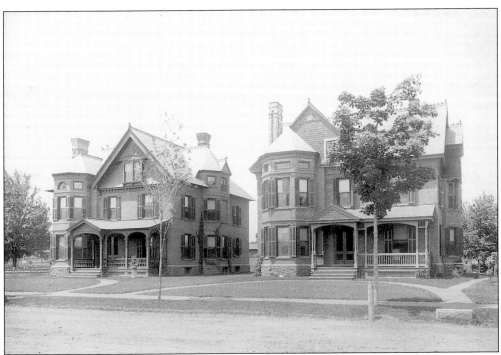

Merwin's Twins. Set in one of the city's most affluent neighborhoods, often called "President's Row" in honor of the industrialists who lived there, are two almost identical houses. Charlotte Hine Stanley's sons, Merwin Clark Stanley and Jesse Stanley, lived side by side. The residences, constructed c. 1885, have changed hands throughout the years but continue to be beautifully maintained to this day. (Local History Room/NBPL.)

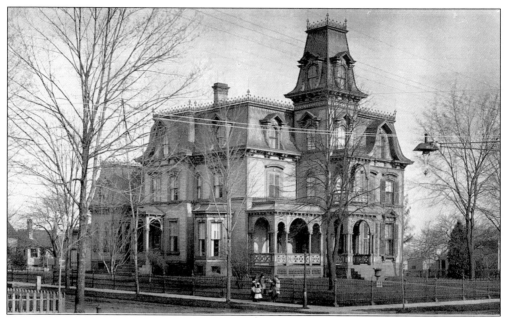

FRANKLIN SQUARE MANSIONS. While many businessmen chose to live on the fringes of the city, others built their homes directly in front of the factories. Two such dwellings are pictured here; they once stood next to each other, on the east side of Franklin Square. The ornate grillwork on the homes and wrought-iron fences are still remembered by many. Today, Liberty Square, the DPUC, and the magnificent new courthouse occupy these sites. (Local History Room/NBPL.)

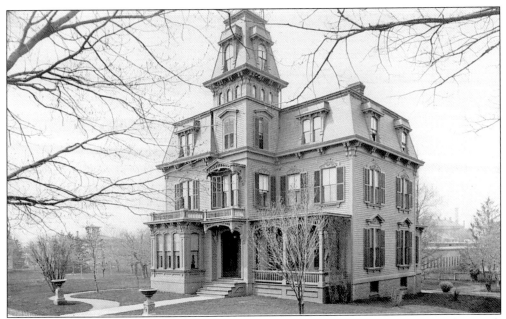

J. ANDREW PICKETT RESIDENCE. Located on Summer Street, the Pickett home and grounds illustrate how rural the area was only a hundred years ago. Not only has the house been razed, the street no longer exists! Naming streets has been enigmatic; there was a Summer, Spring, and Winter Street but never a Fall or Autumn. (Local History Room/NBPL.)

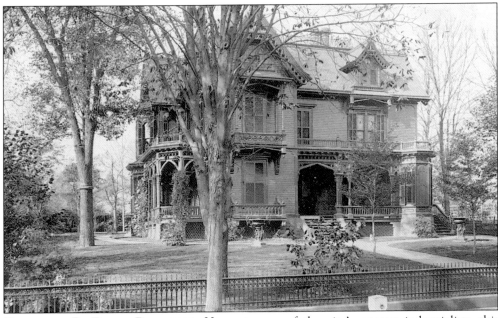

CORNELIUS B. ERWIN RESIDENCE. Home to one of the city's greatest industrialists, this Washington Street dwelling was converted into the parsonage of South Congregational Church. Like many other structures of its ilk, it has not survived the 20th century. Today, businesses, a diner, and apartment houses line this area of the street. (Local History Room/NBPL.)

SUNNYLEDGE. Take an 18-room mansion, include a secret room and a descendent of the Brothers Grimm, and #9 Sunnyledge comes to mind. Built for James North in 1912, it was purchased by Meta Grimm Lacey, who decorated many of its rooms in fairy-tale motifs. (Local History Room/NBPL.)

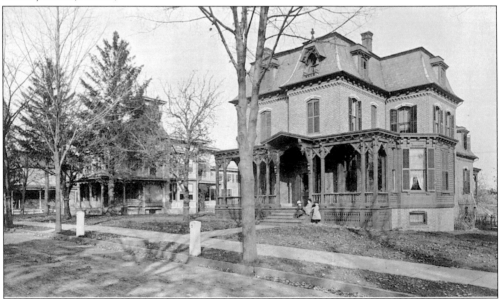

PHILIP AND ANDREW CORBIN RESIDENCE. If ever a name was clearly associated with New Britain industry, it is Corbin. From P&F Corbin to the Corbin Motor Vehicle Corp, the name is synonymous with quality and excellence. The Corbins chose to reside in the downtown area, as is evidenced by their Maple Street home, in order to keep an eye on business. (Local History Room/NBPL.)

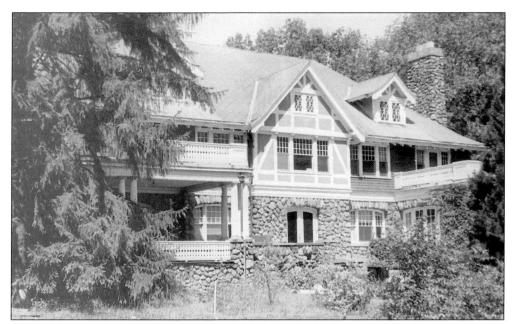

TRAUT MANSION. The mansion on 75 North Mountain Road was one of the luxurious homes of the Traut family. It was set so far back from the main thoroughfare of West Main Street that it was almost invisible. The dwelling had an active second life, first as the location of the Jules Mansion and later as Canberra Laboratories. With little fanfare, it disappeared in the early 1990s. (*Herald.*)

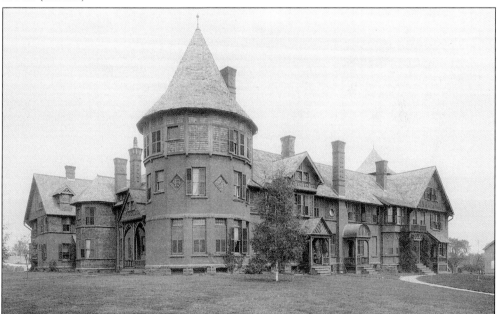

ERWIN HOME. Industrialist Cornelius B. Erwin bequeathed a substantial sum of money ($80,000) for the construction of a home for "worthy, indigent women." The original structure, shown here, was completed in 1892. Additions have been built since the home's incorporation in 1893. The Erwin Home remains a testament to one industrialist's commitment to the community. (Local History Room/NBPL.)

OZIAS B. BASSETT RESIDENCE. Located on the south end of Franklin Square, this homestead at 42 Bassett Street covered a fair amount of land. The square can be seen in the background to the left. The old New Britain High School was built on this site. (Local History Room/NBPL.)

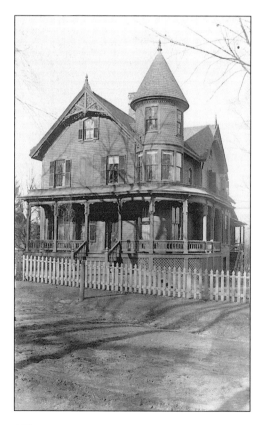

JAMES SHEPARD RESIDENCE. "Lakeside," home of patent attorney, botanist, and genealogist James Shepard, stood on the edge of a small lake. This body of water is better known as Lockshop Pond. Shepard photographed many of the city's buildings; the images have been preserved on glass-plate negatives. and are visible at the public library in the Local History Room. (Local History Room/NBPL.)

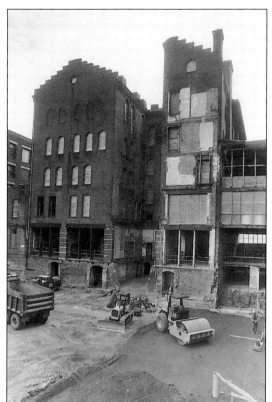

CITY HALL ANNEX, 1990–92. The city's seat of government underwent a major renovation in the early part of this decade. When plans were made to refurbish the old part of the building, it was deemed necessary to tear down the old annex and build anew. Although the main entrance to city hall remains on West Main Street, this Columbus Boulevard entrance, complete with courtyard, hardly appears to be "the back door." (*Herald.*)

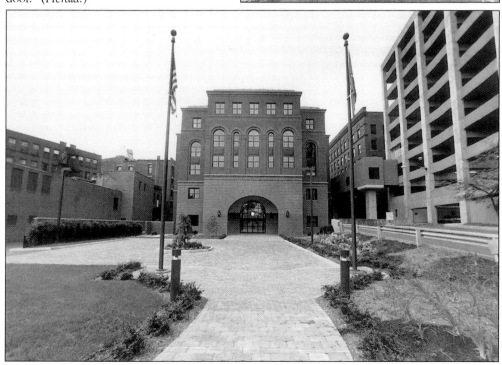

SUPERIOR COURTHOUSE. In a time when many residents look back nostalgically at what New Britain has offered, they can admire the latest addition to the city. The new Superior Courthouse is truly grand and glorious. After decades of new buildings that are reminiscent of large concrete boxes, the courthouse shines like a jewel on Franklin Square. The building brings with it new jobs and an abundance of visiting jurors and legal professionals who may begin to frequent the downtown area. Standing by the South Congregational Church and looking south is rewarding these days. Lower Main Street is refurbished, small businesses continue to open and grow, and at the end of it all is this magnificent new structure. (*Herald*.)

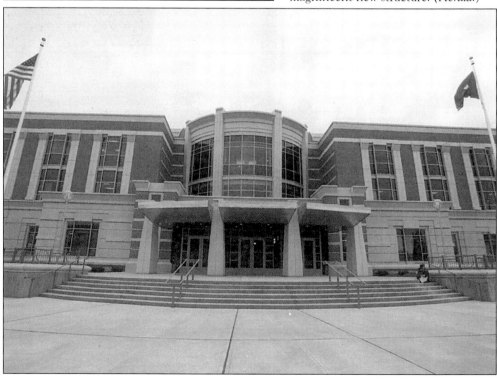

Ten

REMEMBER THE CHILDREN

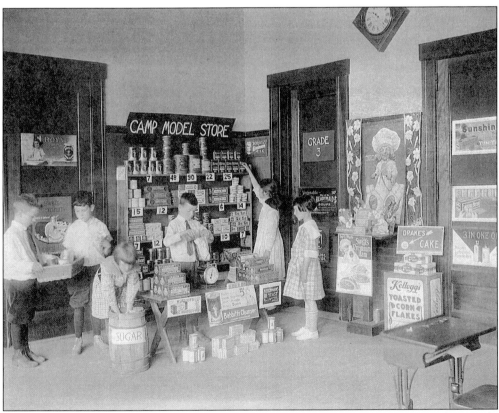

CAMP SCHOOL CLASS C. 1918. Teaching children the value of a dollar never starts early enough. These third graders learned how to buy and sell at their model store. The young students are, from left to right, Byron Jacoby, Dick Gordon, Barbara Christ, Everett Mitchell, unidentified, and Eleanor Zimmerman. The need to instill values in young lives is as necessary now as it was years ago. Today's children are obviously the leaders of tomorrow. (Eleanor Z. Benson.)

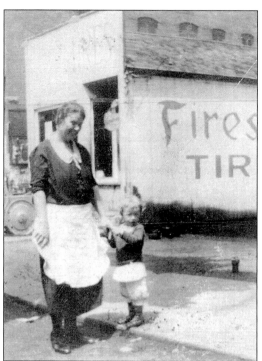

MOTHER AND CHILD, 1925. Ellen Concannon McCarthy and her two-year-old daughter Mary stand outside Ellen's business, the West End Tire Store, at 399 West Main Street. This may have been the forerunner of the "Take Your Daughter To Work Day" that is celebrated now. Charles McCarthy, Ellen's husband, managed the business. (Mary and Matthew Rubino.)

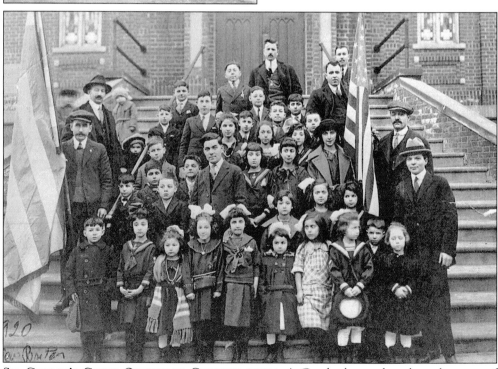

ST. GEORGE'S GREEK ORTHODOX CONGREGATION. A Greek class gathered on the steps of St. Mary's Ukrainian Church, c. 1920, is proof that different nationalities shared space when needed. Although newly settled in this country, many parents did not want their children to forget their native tongue. (Eugenia C. Banios.)

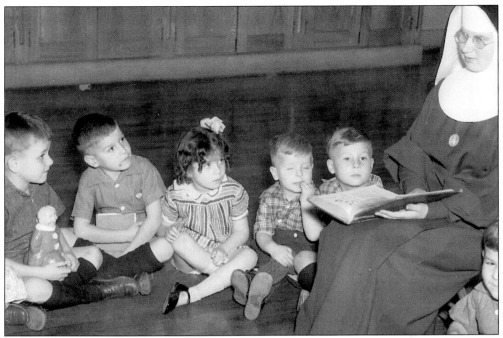

POLISH ORPHANAGE, 1937. Founded in 1904 by Reverend Bojnowski, the orphanage staff worked hard to provide a good home for their charges. A library was established and dedicated in 1937. Pictured here is one of the nuns as she reads to an attentive audience in the new setting. (Local History Room/NBPL.)

VISITING NURSE ASSOCIATION. Young parents receive a helping hand from a visiting nurse in 1947. The organization has helped citizens of all ages since 1905. (Fred Hedeler.)

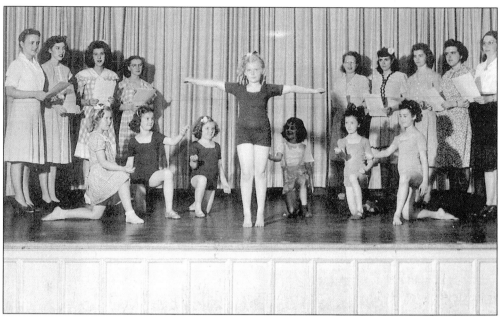

YWCA. A dance recital and international festival are celebrated at the local YWCA. The events taught girls the importance of teamwork and an understanding of different cultures. (Jim and Alison Buckwell.)

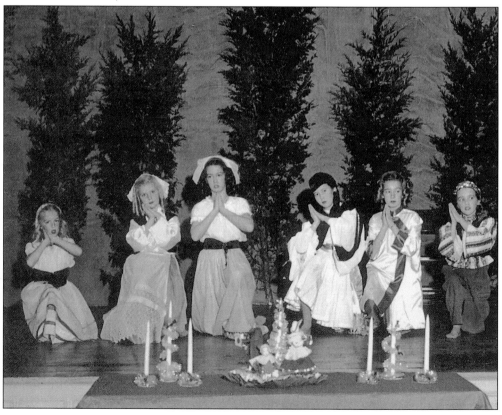

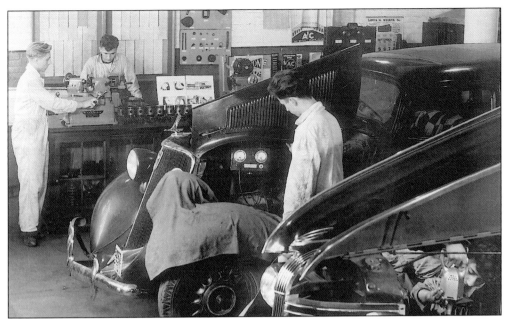

CAR REPAIRS. Young men's fascination with automobiles rarely fades. These youngsters learned the value of knowing what was under the hood and how the highly desirable machines functioned. (Local History Room/NBPL.)

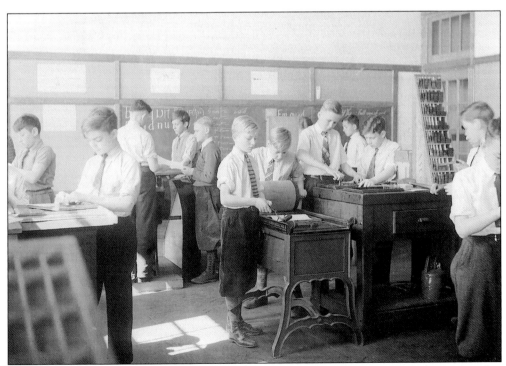

PRINTING CLASS. From setting type, laying out a page, and inking a press to running copy, this printing class taught young men a trade, which, for the most part, has now been replaced by machinery. (Local History Room.)

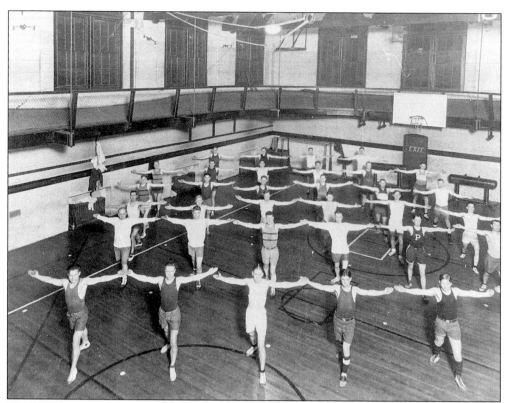

YMCA/CHILDREN'S HOME. Physical education is important for the well-being of all children. Above, a YMCA Senior Physical Training class is held at the old YMCA on Main Street. Below, kids cool off in the Children's Home pool. (Local History Room/NBPL/Klingberg Family Center.)

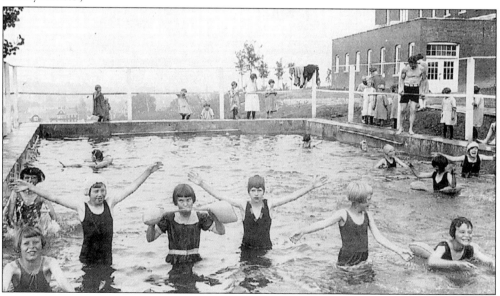

A.W. STANLEY PARK POOL. The parks and recreation department provided young people entertainment and showed them the importance of safety. In 1936–37, boys and girls enjoyed the pool at A.W. Stanley while learning about life-saving techniques from the Red Cross. (Local History Room/NBPL.)

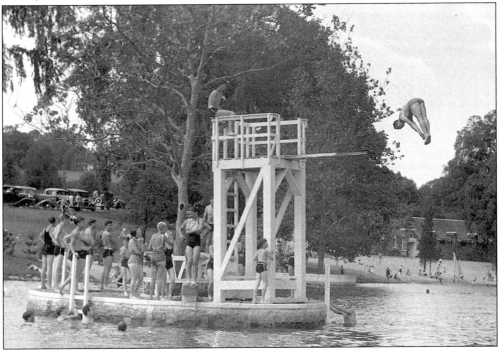

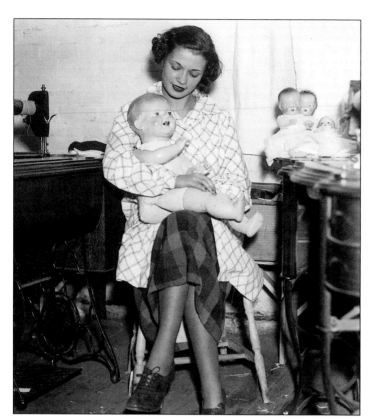

Toy Repair, 1936. The Works Progress Administration (WPA) provided many with useful employment following the Depression. Here a young woman repairs a doll that will, no doubt, bring joy to a local child. (Local History Room/NBPL.)

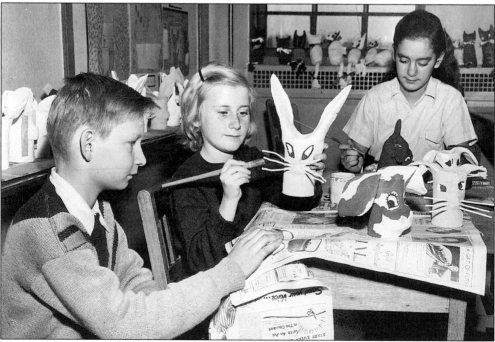

Art Class, 1952. Students at Benjamin Franklin School discovered that making banks out of tin cans and papier mâché allowed for great creativity. (Local History Room/NBPL.)

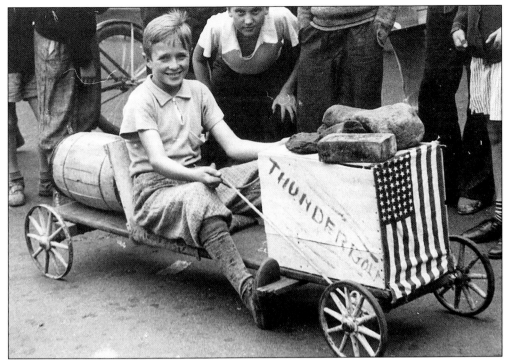

SOAP BOX DERBY, 1936. Who needed a real pair of wheels when a keg, a wooden crate, a brick, a few stones, and four used wheels got this young driver across the finish line? A little imagination and a lot of luck went a long way. (Local History Room/NBPL.)

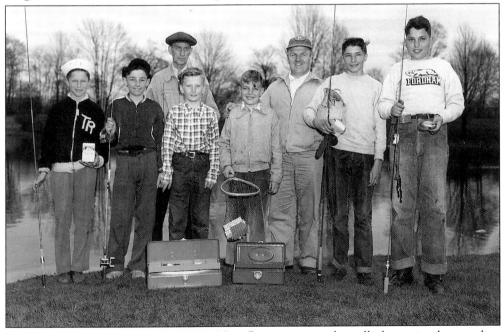

FISHING DERBY, AUGUST 26, 1954. New Britain may technically be a city, but outdoor activities such as skating, swimming, baseball, soccer. and fishing abound. The annual fishing derby was an anxiously anticipated event. (Charles J. Sullivan.)

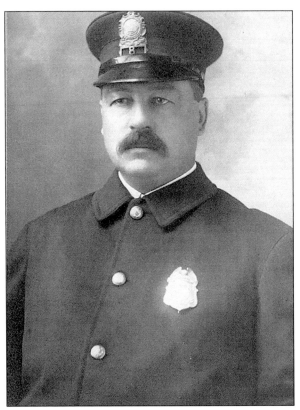

PATROLMAN CHARLES M. JOHNSON AND SHACK, 1903. Patrolman Johnson exchanged the following words with Dr. John E. Klingberg: "I know where there are three boys in a very sad condition and I just wish somebody would go and take them away from where they are." Reverend Klingberg found them in this shack and did as he was asked. This event was the catalyst for the development of the Children's Home, better known today as the Klingberg Family Center. (Klingberg Family Center.)

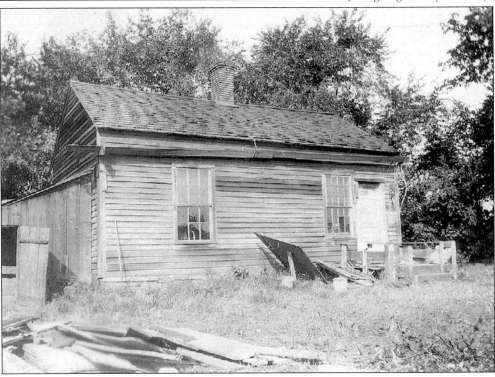

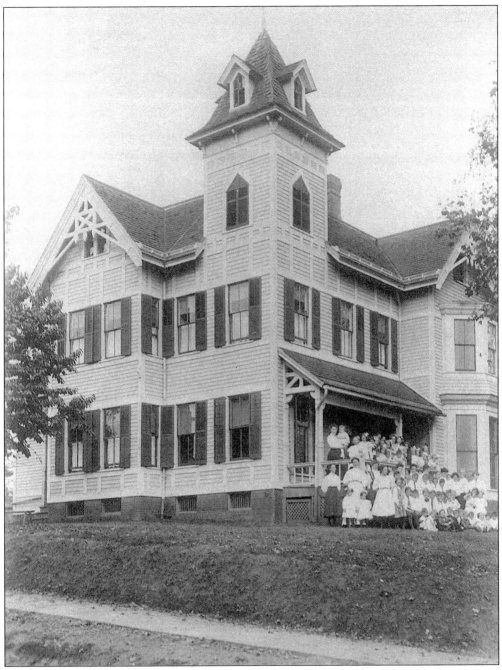

CHILDREN'S HOME, C. 1908. Reverend Klingberg procured several buildings for his growing flock of children before the Linwood Street structure was built. Pictured here is one of the houses the Klingbergs used—the former residence of Judge Burr, on the corner of Hart and Griswold Streets. Reunions are still held at Klingberg today, which allow former residents to congregate, renew old friendships, and rekindle the feelings of warmth and safety they felt under Dr. Klingberg's guidance. (Klingberg Family Center.)

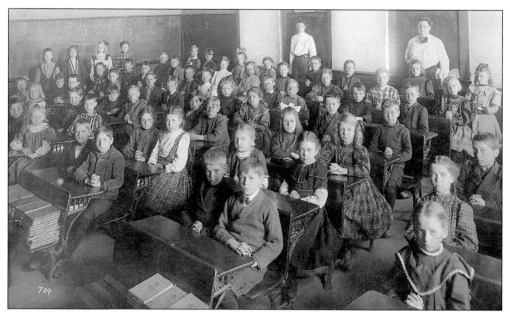

SMITH SCHOOL CLASS. The old Levi O. Smith School only contained four classrooms when it opened in 1880. Space was at a premium, as shown by the crowded conditions pictured here. (Local History Room/NBPL.)

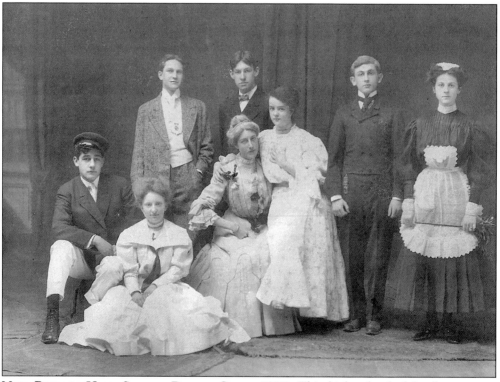

NEW BRITAIN HIGH SCHOOL DRAMA CLUB, 1906. This high school club often put on productions to benefit the senior class. The annual tradition helped with the cost of graduation, an indication that the school encouraged students to be self-reliant. (Richard Barrows.)

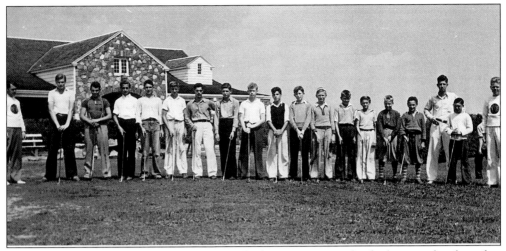

STANLEY GOLF COURSE. One way to earn a little money, enjoy the fresh air, and pick up free tips on the game was to caddie. Golf today remains as popular as it was back in 1936, when this picture was taken. (Local History Room/NBPL.)

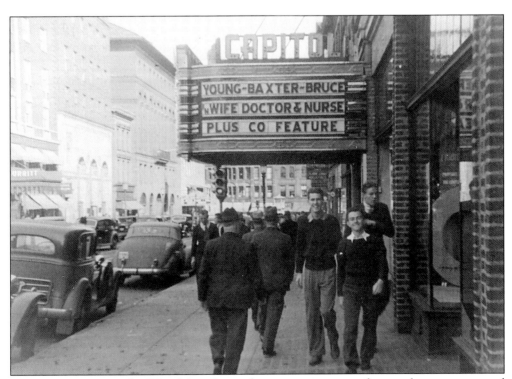

CAPITOL THEATER. The West Main Street theater was just one of seven that once operated in the city. It was a sure bet that kids of all ages could be found here enjoying the latest films. (Local History Room/NBPL.)

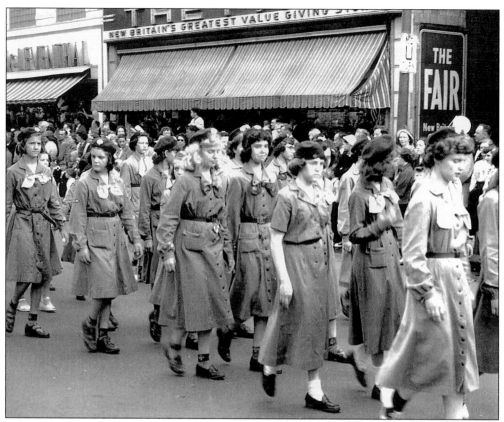

GIRL SCOUTS, 1950. Participating in Memorial Day parades, such as the one pictured here, was always an exciting event. Local girls also looked forward to camping experiences at Camp Sprague on Job's Pond in Portland. (Jim and Alison Buckwell.)

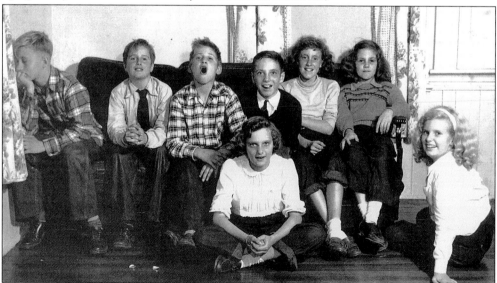

HALLOWEEN PARTY, 1949. Holiday parties brought forth a mix of emotions. Some eagerly anticipate the festivities while others appear indifferent. (Jim and Alison Buckwell.)

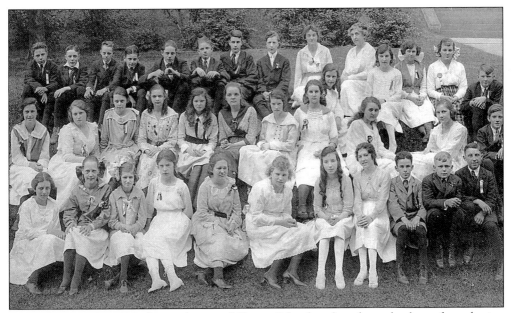

CAMP SCHOOL In 1919 the graduates of Camp School gathered on the lawn for a lasting remembrance of their school days. (Jim and Alison Buckwell.)

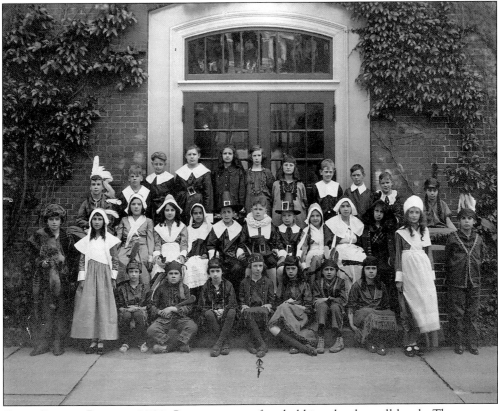

CAMP SCHOOL PLAY, C. 1920. Pageants were often held in schools at all levels. These young participants dramatized the first Thanksgiving, complete with costumes. (Eleanor Z. Benson.)

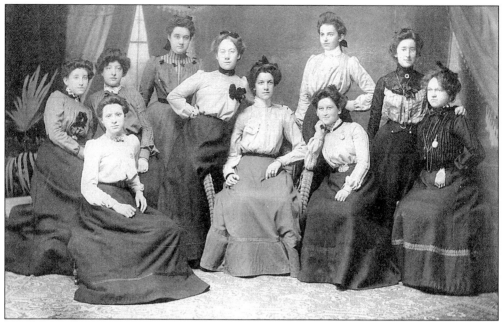

SUNDAY SCHOOL. Pictured is the girls' Sunday school class from the South Congregational Church, c. 1900. Annual meetings were held on the last Friday of September to account for the year's activities, including the state of the treasury and library. (Eleanor Z. Benson.)

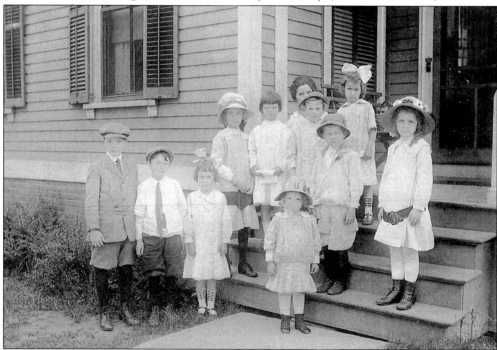

CHILDREN AT MRS. HALE'S. Mrs. Chester F. Hale ran a private school at 100 Hart Street, close to Walnut Hill Park. Some of the students are pictured here, c. 1914. There was an unusual concentration of schools in this area, including the Normal School, Camp School, Camp's Seminary, and Mrs. Hale's School. (Jim and Alison Buckwell.)

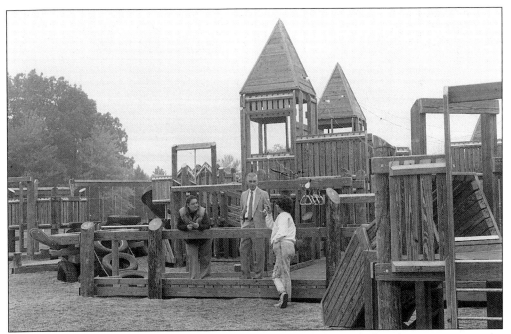

DiLoreto Playground. It took a year to raise the funds, but only five days to construct the playground at DiLoreto School. An estimated 600 volunteers donated hours to make the castle-and-dragon motif come to life. (*Herald.*)

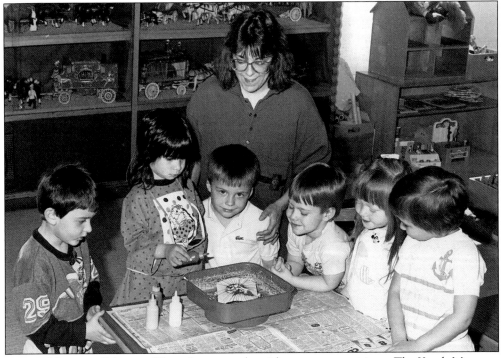

Youth Museum. Educator Gloria Lagosz works with some young visitors. The Youth Museum, a branch of the New Britain Institute, has been introducing children and adults to the arts, different cultures, and animal life since 1956. (*Herald.*)

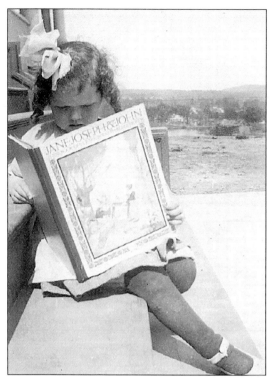

THE PAST AND THE FUTURE. New Britain has gone through incredible changes since its incorporation as a town in 1850. It has evolved from farmland to a major industrial force. The approach of the year 2000 leaves many unanswered questions, including what direction is the city taking. Above, a young reader, a resident of the Klingberg Center, sits on the steps of the home and peruses a book that is almost as big as she is. Below, library staffer Vicki Aiudi reads to her daughter Carolyn on the steps of the Children's Library. It does not matter if the time is the turn of the last century or the eve of the next—the future lies in the hands of our children. (Klingberg Family Center/Allen Butte.)

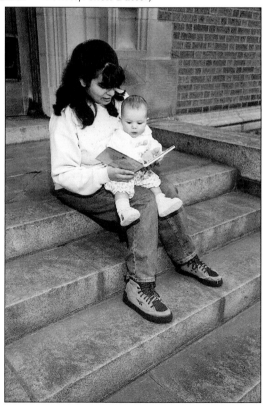